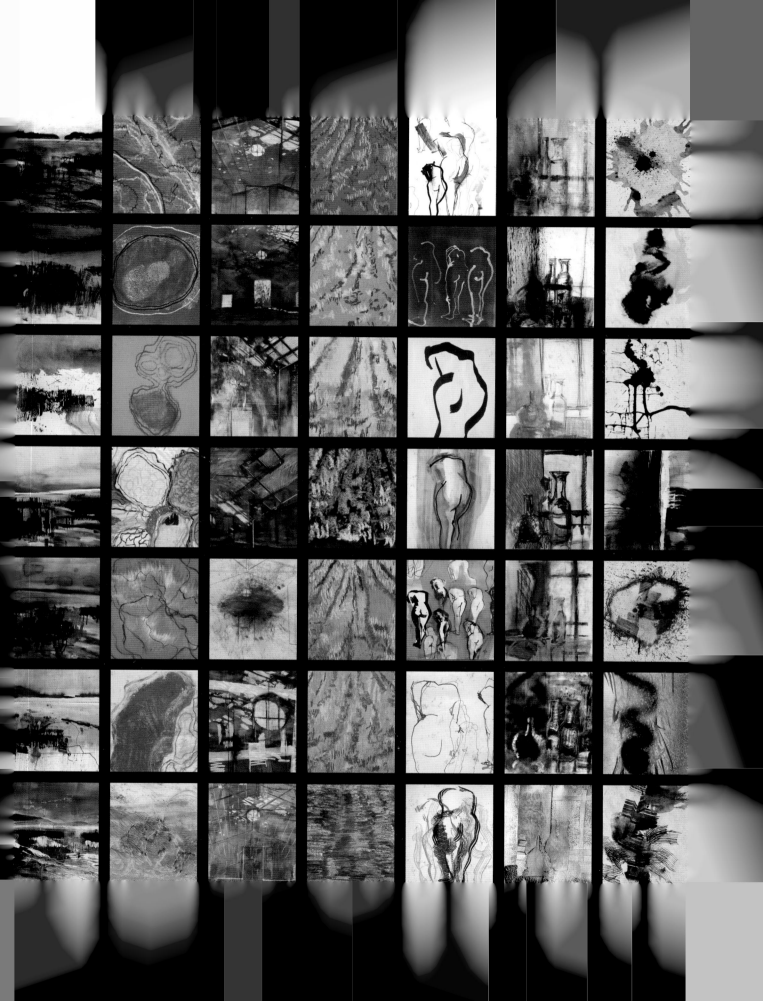

Drawing creative Techniques

First edition for the United States, its territories
and possessions, and Canada published in 2009
by Barron's Educational Series, Inc.

© Copyright of the English edition 2009
by Barron's Educational Series, Inc.
Original title of the book in Spanish: *Dibujo creativo*
Copyright © 2007 by Parramón Ediciones, S.A.—
World Rights
Published by Parramón Ediciones, S.A., Barcelona, Spain

Editorial Director: María Fernanda Canal
Assistant Editor and Picture Archives: Mª Carmen Ramos
Text: Josep Asunción and Gemma Guasch
Graphic Design: Toni Inglès
Photography: Estudi Nos & Soto, Creart
Production Director: Rafael Marfil
Production: Manel Sánchez
English translation by Michael Brunelle
and Beatriz Cortabarria

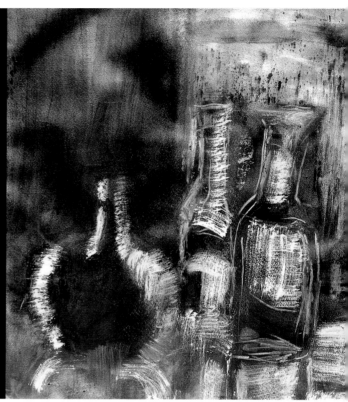

All inquiries should be addressed to:
Barron's Educational Series, Inc.
250 Wireless Boulevard
Hauppauge, NY 11788
www.barronseduc.com

ISBN-13: 978-0-7641-6182-7
ISBN-10: 0-7641-6182-2

Library of Congress Control Number: 2008931206

Printed in China

9 8 7 6 5 4 3 2 1

CREATIVE TECHNIQUES

Drawing

BARRON'S

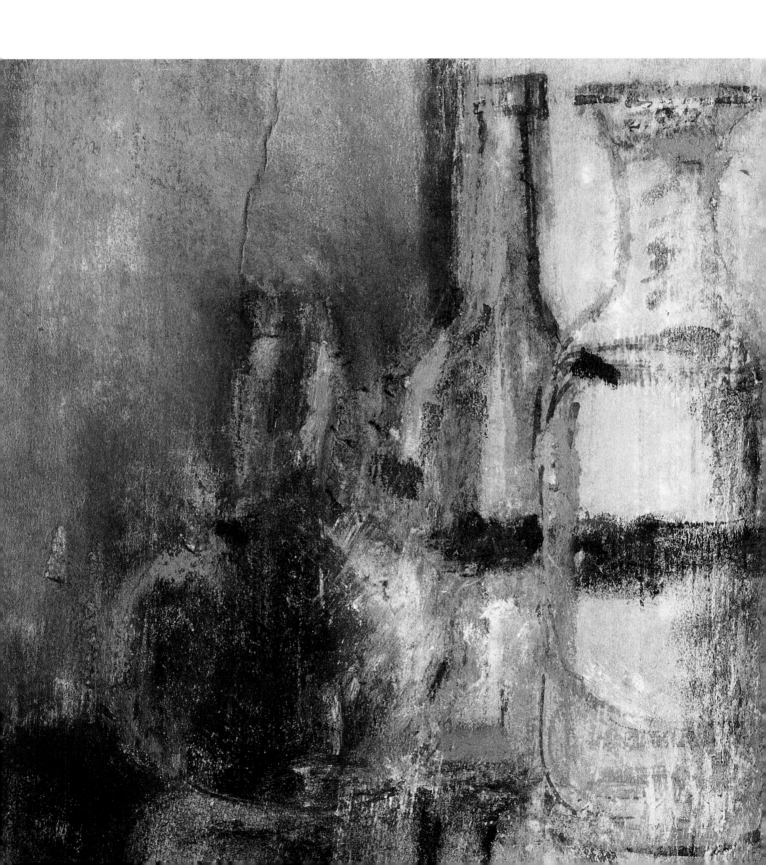

Contents

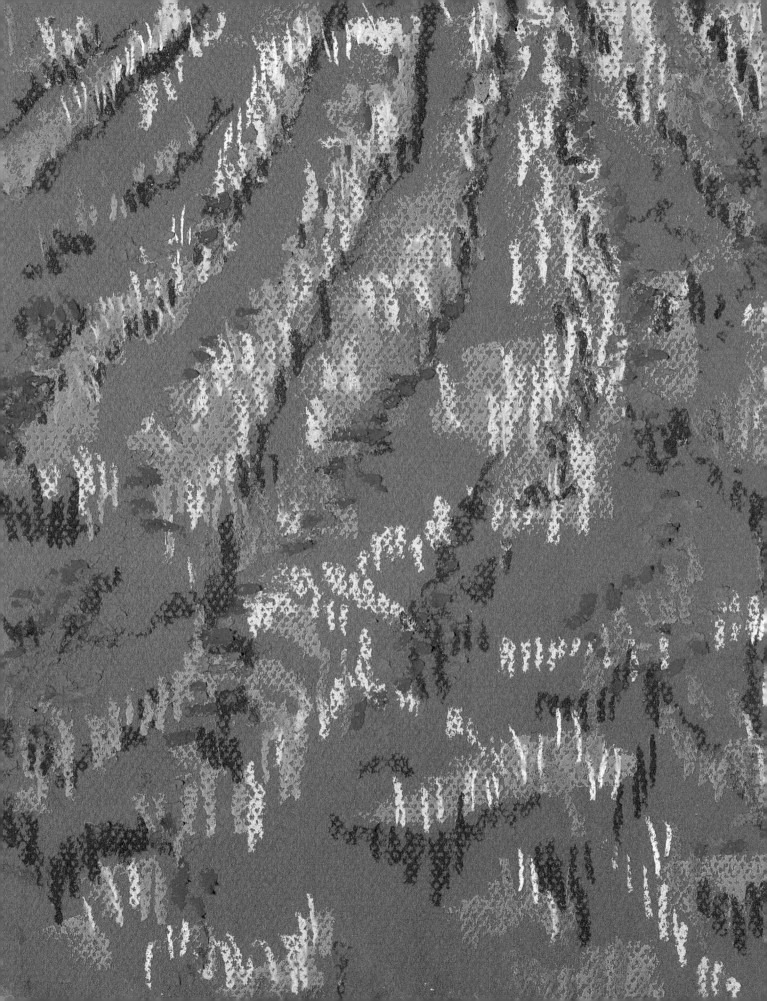

Both authors are artists and professors of painting at the Escuela de Artes y Oficios de la Diputación de Barcelona. Their creative work is the field of contemporary painting and they also investigate new artistic languages in action art, video art, and photography. They have exhibited their work in various cities in Spain and Europe. Their long teaching experience, as well as their work in research and artistic creation, is the basis for the content of this book. Gemma Guasch and Josep Asunción are also the authors of *Form*, *Space*, and *Line* from the "Creative Painting" series published by Barron's. This series is widely acclaimed by an international public that is more and more interested in painting as a means of developing creativity.

Introduction

Ask anyone what drawing is, and the reply will probably include something about communication. A charcoal sketch or a landscape done in India ink are drawings, but so are the floor plan of a house and the layout of an electric circuit. Drawing is fundamentally a language, a method that makes communication possible even for those who speak different languages; it is a way of copying, yet more concrete and trustworthy. Certainly, someone who can draw speaks a universal language.

Outside of the art world, expressions like "draw up a plan," "sketch out an idea," and "having a well-drawn strategy," are used. This use of drawing terminology outside of the artistic environment clearly explains the kinds of activities taking place and hints at other characteristics of drawing—its inventiveness and sense of structure. Drawing helps us visualize an often complex or very abstract reality, creating a basis or the beginning of some kind of work—its foundation if you will. For an artist, creativity and drawing are inseparable. All artists draw, because it is this activity that helps bring to light the ideas that are gestating in the shadows. An artist needs to draw to be able to see with his or her own eyes what is taking shape in the mind. Drawing is, then, a magnificent tool for self-knowledge.

Furthermore, drawing has an essential character, it goes to the root of what it represents and shows its structure and its undeniable logic. The ideal media for this technique are those that are immediate, fast-drying, and simple. Some media, such as charcoal and graphite, have always been used for drawing, and any work made with them is called a drawing no matter what is represented. Ink, pastel, or gouache can be used to create works that either look like drawings, or have a very painterly feeling. In the end the differences tend to fade, and what is a drawing for some is a painting for others.

The Chinese ink landscapes, for example, are considered drawings by many Westerners because they are essentially monochromatic.

In any case, it is a good idea to know the techniques well so they can be used creatively. Language is enriched with a greater number of visual registers, and creativity is a result of the media. New ideas and new challenges are generated from a response to the materials and the techniques. Creativity always supposes an elevated dose of audacity—and often one of transgression. Daring to use unforeseen materials or combining techniques that in theory should not go together opens a door to experimentation and the discovery of new approaches.

Supports

PAPERS

A sheet of paper consists of cellulose fibers of vegetable origin. The fibers may come from the wood of certain trees, such as the eucalyptus or pine, plants like flax and cane, or flowers like cotton. Besides cellulose, a sheet of paper contains glue, or sizing, which is added to give it a certain amount of resistance to water. Without glue, the paper would fall apart when wet. Some papers contain additives that make them glossy, smooth, and stable (coated paper is one example, and inks that give them color).

Each fiber has particular characteristics that make the paper more appropriate for one kind of drawing media or another. Paper manufacturers carefully control the fiber composition of their papers, as well as the amount of sizing and the surface treatment, to create supports that are rigid, flexible, durable, absorbent, rough, or smooth. There are multiuse papers that can be used for both wet and dry techniques. Western and Asian handmade papers, which are made in small mills by artisans using traditional methods, are yet another option.

This paper uses high-quality materials and is very beautiful since it usually has deckle edges and even a watermark.

Fiber

Drawing papers are usually made of cotton, although manufacturers mix these fibers with others to reduce the price and modify some of their characteristics. Rag paper is high quality; it is mainly made from recycled cotton and linen clothing. The linen and cotton fibers, whether recycled or straight from the plants, are the highest quality, as are hemp, manila hemp, and the less common Oriental fibers (*sa*, *mitsumata*, *kozo*, *gampi*, etc.), which are also available on the market. Linen and cotton fibers are very pure, strong, flexible, and porous, and they guarantee a long life for the work of art. Wood pulp fibers, on the other hand, are the worst quality, because they contain other substances that quickly deteriorate, such as lignin and hemicellulose. They are more rigid and less absorbent and are mainly used for mechanical printing and for very durable Kraft paper.

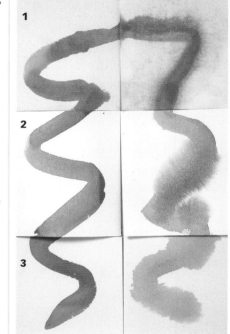

1. Paper with little sizing. *If dry, the ink is quickly absorbed and the brushstroke will look slightly porous and rough. If damp, the ink will bleed to create puddles and irregular brushstrokes.*
2. Paper with a lot of sizing. *If dry, the ink will flow more smoothly in clear strokes without white spots. Ink will, however, accumulate along the edges and appear lighter in the middle. On wet paper the ink will puddle and bleed slightly.*
3. Paper with medium sizing. *The ink flows normally on both wet and dry paper. On dry paper a light charge of ink in the brush will force the porosity of the stroke. Wetting the paper more will exaggerate the bleeding.*

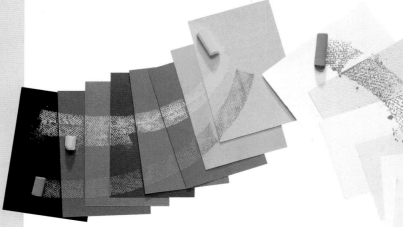

The texture of the paper dictates the look of the line or brushstroke.

f you understand drawing to be a recreational or creative artistic activity, obviously it can be done with any medium, and on any support adapted to the medium: a stick in the sand, chalk on a wall, a heated awl on wood, or a computer mouse. But the traditional support for drawing is the one that has endured through time because of its light weight and adaptability: paper. Canvas, a wall, or wood, are equally valid supports, but are more commonly associated with painting.

OTHER SUPPORTS

Surface

Medium and heavyweight surfaces with a fine grain and smooth finish are usually used for wet techniques when a more or less sharp brushstroke is desired. For dry techniques, textured papers, rather than smooth ones, are used, with a laid texture that works well to hold the pigment from charcoal, chalk, and graphite. Canson paper, with its slight roughness, is ideal for pastel and chalk. For inks there is satin finish Bristol paper with no sizing, and the satin and glossy coated papers that are extremely smooth, but sized.

Weight

The weight of the paper is expressed in either grams per meter or pounds per ream. This is seen in the thickness; paper is considered cardboard when it is more than 260 lbs. Heavy papers are not required for dry techniques, but wet techniques work better with papers of at least 90 lbs because they will not buckle excessively.

Sizing

It is a good idea to be aware of the amount of glue contained in paper, especially when using wet techniques. Glue content can greatly affect the behavior of the brushstrokes and dilution. Watercolor papers usually have a balanced sizing for this reason, but there are papers on the market with both a lot and very little sizing. Consider them according to the effects you wish to create. To test the sizing on a sheet of paper, dampen it with a small amount of water and then observe how long it takes for the water to be absorbed.

Well-sized paper will not absorb water for at least one minute.

If it is not well sized, the paper will absorb the water in seconds.

Besides paper, canvas and wood are also good supports. Practice before using them to make sure you can make good lines on them and that the lines will last. Normally, these supports are prepared with some sort of priming that will guarantee a certain amount of porosity. *Gesso* or an absorbent white or transparent acrylic base are applied to very smooth surfaces, glossy papers, plastics, metals, and even glass. When dry, the white absorbent base looks and acts very much like paper.

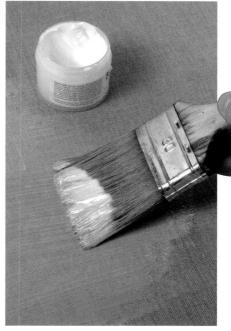
A canvas can be primed with absorbent acrylic. It becomes transparent when it dries.

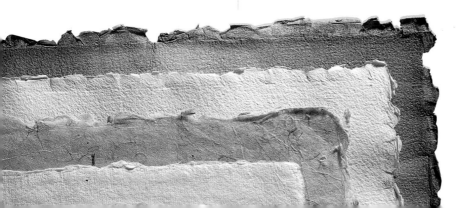
The beauty of handmade paper resides in its textures and natural colors, and in its irregular edges known as deckles.

Creative Techniques: **Drawing**

9

Dry Media

GRAPHITE

Graphite is crystallized carbon that is mixed with clay, pulverized, and cooked to make it solid and create different levels of hardness. It is available in different forms: pencils, sticks of different thicknesses, and powder.

Graphite Pencils

These are thin sticks protected in a wood sheath. Universal norms were established to identify the levels of hardness, the letter B is used for soft pencils and the letter H for hard ones. These letters are preceded by a number. Hard pencils, with lighter tones, go from 9H (the hardest) to H, and soft pencils, which make darker tones, range from 9B (the softest) to B.

Graphite Sticks

These are found in the form of a pencil protected with a plastic holder, or as square or rectangular sticks ideal for making large shaded areas. Since the sticks are not limited by any covering they can make a wide range of lines. Water-soluble graphite sticks are softer, and can be wetted directly. A wet brush can also be used over the graphite already on the paper.

Graphite and Charcoal Powders

These are sold in containers and are usually applied to the paper with a cotton rag, a soft brush, a blending stick, or directly with the hand. They cover large surfaces quickly and create soft and atmospheric shadows.

COLORED PENCILS

These are composed of pigments bound with kaolinite, talc, or chalk, and an agglutinate, usually cellulose glue. They are used in the same way as graphite pencils, but their finish is less oily, smoother, and satin. They can be used in different ways: a linear approach similar to that of graphite pencils, but with color, or a softer, more delicate use of blending.

Water-Soluble Colored Pencils

These are made with color pigments bound with waxes and varnish that include a soluble element that allow them to be dissolved. They are used like normal colored pencils, but water is added to them later. The water dissolves the pigment and creates areas of color that can continue to be worked after drying.

CHARCOAL

This is the most primitive drawing medium. It comes in the form of sticks, pencils, and powder. It is important to apply a fixative or lacquer after the drawing is finished to ensure its adherence.

Charcoal Sticks

There are two types: vine charcoal and compressed charcoal. Vine charcoal is simply a twig of carbonized beech, willow, or grape without any kind of glue or agglutinate; it is unstable and brittle and makes lighter tones. Sticks of compressed charcoal consist of pulverized black pigment mixed with an agglutinate, and they are darker, denser, harder, and make a less delicate line.

Charcoal Pencils

These are charcoal mixed with graphite, soot, or pigment bound with clay, which comes in varying grades of hardness according to how much clay is used. Their line is black and they can be sharpened.

Dry media can be worked in a simple manner, without a lot of pretensions. Using a pencil, a piece of chalk, or a stick of graphite, you can make a drawing without difficulty. A drawing made with dry media can be made directly on almost any surface without previous preparation. You can grab a pencil at any moment and make a sketch or express an idea. The drawing's strength is in its quickness and simplicity.

CHALK

This is the name given to the hardest pastels. Chalk's composition is very similar to that of pastels: pigment with glue, hardened with resin. The most common are white, black, sanguine, and sepia, but there are a large variety of colors. They are used for hatching and blending, and are available in stick and pencil form. When the drawing is finished fixative or lacquer must be used to conserve it.

Sanguine

This chalk, used since Renaissance times, has its own name. It is made from iron oxide pigment that gives it a characteristic reddish color.

PASTELS

These are available in sticks that are hard or soft according to how much agglutinate they contain.

Dry Pastel

These are made with pigment mixed with a base of plaster and bound with glue. Soft pastels have velvety, light tones, ideal for rubbing and blending. They contain more pigment and less binder, and therefore break more easily. Hard pastels have less pigment and more agglutinate, and can be used for making loose and contrasting line work.

Oil Pastels and Wax Sticks

These are sticks of color bound with wax, oils, or polyethylene. They are spread easily and can be dissolved with essence of turpentine or paint thinner. One type is a water-soluble crayon made with glycol (a water-soluble agglutinate).

MARKERS

Markers originally had felt tips, but the tips are now polyester. Inside is a wick soaked with ink (soluble in alcohol) that ascends to the tip through capillary action. Markers dry quickly and are easy to use. They are available in several widths: very wide, very fine, and with tips that look like brushes. When dry they can be opaque or semitransparent, but they are almost always very bright.

1. *6B graphite pencil*
 HB graphite pencil
 6H graphite pencil
2. *Graphite stick*
3. *Water-soluble graphite stick*
4. *Colored pencil*
5. *Water-soluble colored pencil*
6. *Charcoal stick*
7. *Compressed charcoal stick*
8. *Charcoal pencil*
9. *Chalks*
10. *Dry pastel*
11. *Oil pastel*
12. *Wax pastel stick*
13. *Dry pastel pencil*
14. *Fine-point marker*
15. *Wide-tip marker*
16. *Brush-tip watercolor marker*
17. *Water-soluble wax stick*

A basic set will also include the necessary materials for creating bases, fixing, erasing, and blending.

1. *Resin and alcohol-based fixative. Protects drawings and seals them to the support.*
2. *Sharpener. Indispensable for detailed pencil drawings.*
3. *Primer base for wood and canvas.*
4. *Kneaded eraser. Ideal for charcoal and pastels.*
5. *White eraser for pencils and chalk.*
6. *Eraser with holder. Makes it easy to erase details.*
7. *Blending stick for rubbing.*

Wet Media

MATERIALS

Even though all water-based paints can be used to draw, some are more appropriate than others, because they can be used on paper, dry quickly, and do not build up. Inks and gouache are examples. Others are more appropriate for painting than for drawing because of their material dimension (acrylics, for example), or because of the support they require (for example, canvas, wood, or walls) are needed for tempera and frescos).

Inks

India ink is one of the oldest and most traditional media used in the Orient. It is water soluble, so its concentration can be adjusted to achieve different tones when it is gradated. It is applied with a reed pen, brush, or nib pen and is available as a liquid in containers, or in solid cakes that are diluted by rubbing on a special stone. India ink is made with carbon black and gum arabic. It looks slightly viscous, and once it dries it is waterproof.

Artist-quality inks have a similar composition to India ink, but use colorants instead of pigment. Black artist-quality ink is more liquid than India ink, and it is manufactured with black dye or with salts and pigment. The colors are transparent and not very permanent; they fade with time and with the effects of sunlight.

Writing inks are used for filling fountain pens; they are fast drying and have an alcohol base. The most popular ink among artists is Quink by Parker; it is currently available in blue, black, green, and blue-black colors, and offers many additional shades when diluted with water. If bleach is applied, beautiful effects of light can be achieved.

Gouache

This medium is also called tempera or opaque watercolor. It is diluted with water and is composed of pigment and gum arabic. Like ink and watercolor, it is applied on paper, but gouache is denser and thicker than the others. Thanks to its opacity, it can be applied on dark papers with brushes or rollers. It is not good for applying impastos, as it cracks when it dries, nor is it useful for glazing because of its opacity. When dry it has a flat, matte finish.

Other Substances

There are many substances that alter surfaces colored with ink to produce various and surprising effects. Bleach "eats" the ink, leaving behind a beautiful and luminous tone that ranges from white to yellow orange, depending on whether it was applied undiluted or mixed with water. Salt absorbs ink where it is deposited and creates a beautiful mottled texture. Alcohol lightens the tone of the ink and makes it lighter and transparent, creating small puddles with soft rings at the edges. Any oily material (oil, wax, essence of turpentine, etc.) creates a reserve that will keep the ink from adhering wherever it has been applied; and if an oily medium like essence of turpentine or cobalt dryer is mixed with a water-based paint, brushstrokes with textural effects will result because the paint will not emulsify.

1. *Ink stick*
2. *Quink fountain pen ink*
3. *Gouache*
4. *Liquid India ink*
5. *Artist quality colored ink*
6. *Bleach*
7. *Salt*

Wet drawing media require the use of a solvent (water) and applicators (brushes, reed and nib pens). Working with these techniques requires equipment and preparation: containers to hold the water and clean the applicator, rags, tape to secure the paper, boards to fix them to, etc. Wet media are very satisfying and versatile. Their effects vary according to the applicator and how wet the material is.

APPLICATORS

When working with ink or gouache it is important to choose the appropriate applicators, either rigid nib and reed pens, or softer brushes and sponges. The ability of each applicator to hold a charge depends on its design and the materials from which it is made. The applicators' expressive characteristics are determined by their size and shape.

Nib and Reed Pens

These rigid applicators are used with ink, and retain the liquid inside a hollow area. The reed has a naturally-occurring hollow, while the metal nib pen sports a concavity and sometimes a formed area that will hold a larger amount of ink. There is a great variety of pens, some are especially made for calligraphy, but can be just as useful for drawing. The nibs and the holders are usually interchangeable.

Brushes

The best brushes for wet media are the ones made for watercolor, which is a water-based medium, rather than oil. Inks and gouache are applied in a liquid or fluid state, and never creamy or pasty. Wide brushes can be used to make large brushstrokes, paint backgrounds, and for blending and making gradations. Ox, sable, and squirrel are the ideal hairs for brushes, but the latter two can be expensive. There are also very high quality and reasonably priced brushes made with synthetic hair. Don't use these with bleach, essences, and solvents.

Chinese brushes come in many compositions, thicknesses, and lengths according to the requirements of the painters and calligraphers. Their major characteristic is a greater capacity for holding a charge of ink or paint. They are made of the following or a combination of the following: squirrel hair, wolf, ox, and even lamb, which can be used to make very long brushstrokes without recharging the brush.

Sponges

The sponge is a very useful applicator because of its great absorbance and softness. They can make gradations and strokes with rich modeling, as well as remove ink or paint by wiping across the drawing to create a light wash. There are many kinds of sponges. The softest are the natural ones, ideal for general washes; the stiffer ones are sold with handles and a flat piece inside that gives them shape; they are ideal for clear brushstrokes with light, flat, and gradated effects.

1. *Round tip nib*
2. *Fine point nib*
3. *Wide nib*
4. *Reed pen*
5. *Thick round ox hair brush*
6. *Thin round ox hair brush*
7. *Chinese brush*
8. *Brush with cartridge*
9. *Wide synthetic hair brush*
10. *Fan brush*
11. *Flat sponge brush*

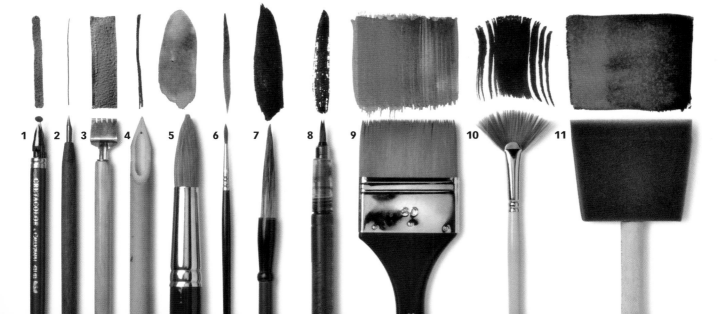

1 2 3 4 5 6 7 8 9 10 11

Basic Techniques

PENCIL

Since pencil is more of a hard medium than a soft one, it is perfect for making precise lines. This precision is apparent as lines and as shading, especially when working with hatching. When it comes to blending, graphite allows for more adjustment of gray values than any other medium. Make use of the hardness of the leads and the pressure used when applying it to the support. On the other hand, it is very difficult to create random textural effects with it unless transfers are made by *frottage* or work is done in a very loose and free way, drawing and erasing.

Drawing lines, hatching, and gradation

The advantage of this medium is that the hardness of the lead can be varied as needed, in addition to applying more or less pressure on the stroke. The speed and modulation of the stroke will also enormously influence the final result. Keep an eraser handy, not only to erase mistakes, but also to create lines on shaded areas.

Gradating grays varying the hardness of the pencils. *Darker grays and heavier blending can be achieved with the soft leads (from 9B to B). The hard ones (H to H) can be used to make very light grays and subtle blends, as long as you don't press too hard and damage the paper.*

Drawing a gestural line, varying the pressure as the line advances. *The varying of pressure or shape (angled, sinuous, choppy, etc.) is known as modulation of the line. It is important to practice it to be able to enrich the drawing.*

Loose shading. *This is the natural hatching of the pencil when shading is created, since the point of the pencil is always used, whether it is sharp or dull. Before shading, think about the hardness of the pencil; it will affect the gray tone and the sharpness of the lines.*

Blended shading. *Making light, careful shading without applying much pressure creates blended shading. Later you can rub with your fingers to fill in the grain of the paper and spread the graphite.*

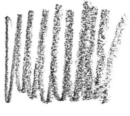

Eraser hatching. *You can create drawings by erasing over hatched and blended shading. Erasing is easier when there is less graphite on the paper.*

GRAPHITE

Graphite lets you achieve effects very similar to those of pencil. However, it is not very useful for small format precision work because it is soft (from 9B to B) and is not applied with a sharpened point.

Drawing modulated lines and shading using the shape of the stick

Graphite is more useful than pencil for making modulated lines and shading. The whole stick—the point, the edge, and the side—is used whether covering a large area or just making a mark.

Lines with the point of the stick. *Drawing with the point is most similar to a pencil line. In this case, the stick is of medium hardness (3B), and the result is a light gray.*

Lines with a dull point. *Lines made with a rounded point (typical of graphite) are wider and less dense. Since this stick is quite soft (6B), the lines are darker.*

Lines with the edge of the stick. *This is a very expressive way of making modulated lines. When the stick is square or hexagonal the edge is often used to make lines like this.*

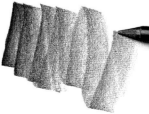

Among the **dry media** (pencil, graphite, charcoal, chalk, marker, and pastel—dry or oil) we identify five basic techniques: drawing lines, shading, hatching, blending, and erasing. Some dry materials are soluble and present a sixth technique: the wash. Among the **wet media** (inks and gouache) we identify four basic techniques: drawing lines, shading, hatching, and textural effects, of which there are many kinds (glazing, gradations, blends, etc.), depending on whether they are applied on dry or wet paper. Each material responds differently to the different techniques, a fact that must be taken into account when deciding which one to use for a drawing.

COLORED PENCILS

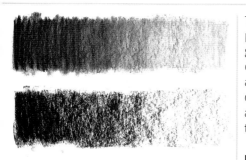

The basic techniques used with colored pencils are the same as those used with graphite pencils. However, colored pencils add more options when blending and hatching, because by combining different pencils color mixtures can be achieved on paper or in the retina of the viewer.

Drawing lines, hatching, dense and washed shading
The natural way of drawing with colored pencils is to use the point to make lines and hatching. It is possible to create uniform areas of color, but to do so requires patience.

Colored lines made by three different leads (from left to right: hard, soft, and water-soluble) on three different papers (from top to bottom: watercolor, conventional, and glossy). The choice of paper and type of pencil are key.

For this medium, it helps to be radical. Either keep the work soft and blended, without applying much pressure to the colored pencils, or press hard to create dense shading and strong contrasts.

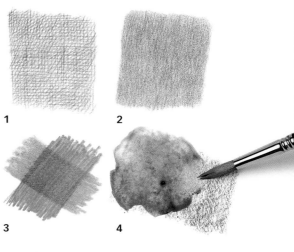

Gradations. The normal manner of making gradations is to increase or decrease the pressure on the stick, which should be angled or on its side. The effect is not dense and reveals the texture of the paper. Blending the gradation causes gray tones to appear and the gradation is softened.

Shading with powdered graphite
Used dry powdered graphite is perfect for creating very soft and atmospheric effects. If it is water-soluble it can be diluted to make beautiful washes. Any work of art can be enriched by combining powdered graphite shading with modulated or hatch-line work.

Powdered graphite shading. To take full advantage of the softness of this material, apply it with cotton (if it is dry) or with a wide soft brush (if it is diluted).

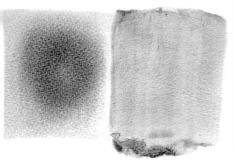

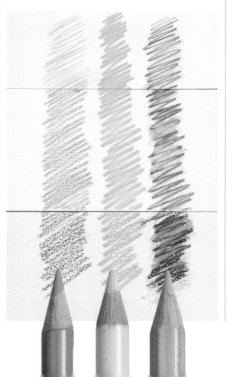

1. Mixing colors with crosshatching. *Overlapping hatching will blend in the viewer's retina.*
2. Blending colors. *Use light shading to make mixtures on the paper. The pressure must be controlled since heavy shading will prevent later applications. Several layers are usually applied until the paper is saturated.*
3. Dense shading. *The result is more radical and colorful. This technique requires controlling the direction of the line, maintaining uniform rhythm and direction.*
4. Watercolor shading. *The water blends the colors and creates very interesting textures.*

Basic Techniques

CHARCOAL

When using the basic techniques, give the same importance to the charcoal stick, the rag, the eraser, and the hand, because all these materials are used for making freehand lines, hatching, and blending. Working with charcoal is like modeling: you add and subtract matter until you reach your goal.

Drawing lines and shading with stick, powder, and eraser

Just as with graphite, different qualities of line can be achieved according to how you apply the charcoal to the paper. If you are using a vine charcoal stick, the powder on the paper disappears easily, allowing free use of the rag and eraser to effortlessly create white areas. Compressed charcoal is more permanent and is harder to erase, although it makes darker blacks.

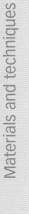

1. *Lines made with the point create a strong linear effect.*
2. *Lines made with a chisel point are wider and more textured.*

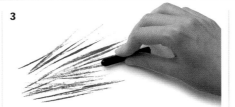

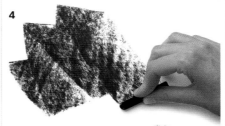

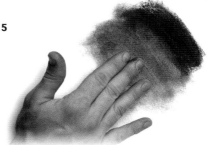

3. *Lines with the side of the stick are very thin and straight.*
4. *Strokes made with the side of the stick create shading and large surfaces.*
5. *Blending strokes with the hand. Rubbing fills in the texture and creates soft and atmospheric shading, as well as gradations.*

Erasing with a rag and eraser. The mark of the rag is less precise and creates texture and atmosphere. The eraser makes a sharper mark, which can be very precise if a white eraser is used instead of a soft eraser.

CHALK

Chalk is very similar to dry pastels, but harder and oilier. It has the advantage of being able to be mixed with pastels, and also with pencil and compressed charcoal. Chalk is always worked dry, but it is possible to dilute it with water to make simple washes.

Modeling lines and making hatching, blends, and washes

Making lines and strokes with chalk is very similar to using charcoal, but since it is denser, the line is more intense. If it is blended, the texture of the paper will be completely covered. It is interesting to combine lines and shading to create light and dense areas.

Direct drawing and blending. The direct approach lets the texture show through, while blending creates soft shading and color mixes.

A wash with diluted chalk.

Modulating creates textural effects.

Parallel line hatching.

16

PASTELS

Pastels are the softest and most malleable of the dry media, although harder pastels that are similar to chalk exist. Their greatest advantage is the ease with which they can be blended. Even though they are normally used dry, washes can be made by wiping them with a brush dampened with water (dry pastels) or with paint thinner (oil pastels).

Making lines with dry pastels

The logical use of pastel is for areas of color, although it can be used to make heavy lines with soft edges. The most common pastel line is very blended and atmospheric and combines well with overlaid hatching or lines. It is very typical to work in layers, fixing each layer well before moving to the next one. This way beautiful densities and chromatically rich textures are achieved.

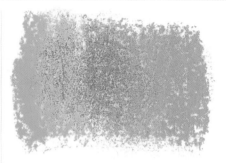

Gradation with blended colors.

Diluted with water. The pigment spreads, although most of it accumulates in the texture of the paper.

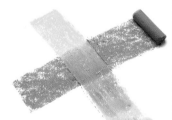

Overlaying colors without fixative. Each color streaks and blends.

Overlaying colors with fixative between layers. The pigment of the lower color stays in place.

Overlaying bright strokes. Hatching applied over gray tones or blended shading produces very painterly effects.

WAX CRAYONS

Wax crayons are greasy pastels, just like oil pastels and oil sticks. The basic techniques of this medium are the same as for dry pastels, except for the dry blending, which is very difficult because of the pastiness of the material. Warming the crayon in your hands or with the help of some kind of heater will make blending easier.

Making lines with oil pastels

Wax lines are greasy and pasty, and they have very painterly thick and thin areas in the stroke. Working in layers can create sgraffito, in which lines are scratched in a top layer to reveal the color beneath. The choice of support is very important. If the support is too smooth it will affect the density of the stroke, and may even cause surface slip if it is too glossy. Apply thinner or essence of turpentine to the wax to achieve very interesting washes, similar to those seen in oil paintings.

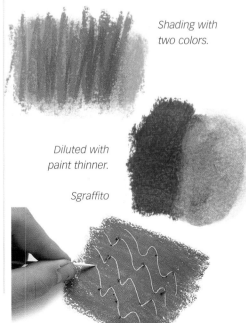

Shading with two colors.

Diluted with paint thinner.

Sgraffito

Basic Techniques

MARKERS

Markers are natural tools for making lines. For shading, you will need to fill the space with accumulated lines or hatching. Some watercolor markers allow you to make controlled washes by passing a wet brush over their marks, but most marker inks are permanent and can be diluted with alcohol.

Experimenting with different widths, densities, and strokes

Happily there are many kinds of markers available that can make very different strokes, depending on their width, the shape of the point, and the density and composition of the ink. Making slow lines or pausing briefly at the end of a line creates a small spot of accumulated ink that can be put to expressive use. On the other hand, drawing very quickly or applying little pressure makes a streaky, broken line. It is very interesting to experiment with hatching that combines different line widths, colors, and modulation.

Slow strokes with pauses.

Loose hatching of various sizes.

Quick dragging strokes.

Modeling by hatching.

Experimenting with opacity.

INDIA INK

Ink is far and away the best wet medium for drawing. It can be used on dry or wet supports and with many different levels of dilution or concentration. The applicator is important when it comes to the desired type of line; a line made with a nib pen is very different from one made with a sponge brush.

Drawing on dry and wet paper

The key to working with India ink is knowing whether to apply it on wet or dry paper, or to combine both. Water is the medium that allows the creation of gradations; natural gradations can be made by letting the ink spread freely or by controlling it with a brush or sponge, carefully wiping the ink across the wet paper. Water will also create white spots in an ink wash.

The same strokes on dry and wet paper vary enormously. On wet the color lightly bleeds to create unforeseen accidental textures: streaks, puddles, relief, and even crackling effects. On dry paper the texture is visible and creates bright spots.

Natural gradation.

Brushed gradation.

Gradation made with a sponge brush.

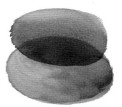

Making highlights with water is possible when the ink is not completely dry.

Glazing with overlaid brushstrokes. The gray tones accumulate and create depth.

Creating hatching and textural effects

One of the most interesting areas of experimentation with India ink is that of visual textures. Ink on paper is a world to be discovered; it can take on lights and shades as well as incredible textures when it is approached creatively, working with the dampness of the support or the use of other additives like alcohol, turpentine, cobalt dryer, bleach, and sea salt. Wiping the drawing with a sponge or rinsing it directly under the faucet when it is partially dry also creates very interesting effects. Another common, though less experimental, approach is the use of hatching done with nib pens, reed pens, and brushes with fan-shape bristles.

ARTIST'S INKS

Crackling spreads on puddled water.

The effects of sea salt on wet ink.

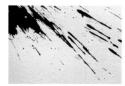

The effects of alcohol on wet ink.

The effects of turpentine mixed with ink.

Spattering.

Dripping created by drawing on an upright sheet of paper.

Nib pen hatching.

Reed pen hatching.

The main characteristic of artist's inks is their transparency. Though they are often called liquid watercolors, they are more transparent than watercolors because they use aniline dyes rather than pigments. Most colored ink techniques are similar to those of India ink, which acts differently because of its composition and density. Fountain pen and calligraphy inks are included in this group. Although they are more opaque than the other inks, they act in a similar manner.

Experimenting with the transparency of colored inks

Because of their transparency, magnificent glazes can be made with colored inks by overlaying areas of color, or lines drawn with a pencil dipped in ink. The effect is a stroke of color with a dark thread of line in the center. Drawing over a dry patch of ink with a pencil or reed pen dipped in bleach creates a very beautiful white line. A sponge can be used to make light gradations and modulated colors; try charging the sponge with various colors that will blend on the paper. Finally, it is very interesting to combine hatching of different colors, which will blend both on the paper and in the eye of the viewer.

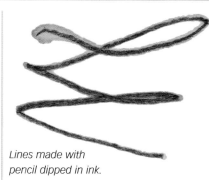

Lines made with pencil dipped in ink.

White lines made with pencil dipped in bleach.

Stroke made with a sponge.

Glazing with colors.

Overlaid color hatching.

Basic Techniques

GOUACHE

Gouache is an ideal medium for making flat and opaque areas of color, which is why it was traditionally used for illustration, posters, and animation. Even though it can be more or less diluted, gouache will become neither very transparent nor completely pasty or creamy. This is seen in the brushstrokes, which are dense and viscous. Its denseness makes it possible to make brightly colored drawings on dark colored backgrounds.

Covering surfaces with strokes of different densities

Very diluted gouache becomes translucent and satiny, with puddles and light and dark areas within the brushstroke. With a little less water it becomes dense and viscous and makes uniform, flat areas of color. Directly from the container it is very dense; it will not flow adequately from the brush to reveal the texture of the paper beneath. Any of these three states of gouache are valid if the resulting effects are desired.

Brushstroke showing three different effects: very wet translucent paint, dense viscous paint, and dense and textured paint.

Dense and flat strokes of color.

TRANSFERS

There are many techniques for making transfers that can be applied to drawing. Direct transfers are the ones that result from direct contact between the object and the paper: the impression and *frottage*. The indirect method refers to when a printed image is transferred, normally using acrylic gel or solvents.

Transferring images, colors, and textures

To transfer printed or photocopied images you can use solvents applied to the back of the print with light rubbing, or glue the image with a polymer gel and then remove the paper by wetting it to leave the ink on the support. The advantage of the first method is that it can be applied to paper, but the image does not always transfer well and it is toxic. The second method is more reliable and not at all toxic, but you must use supports that resist water, such as canvas, canvas board, heavy cardboard, or wood.

A monotype is a transfer of a drawing made with an oil medium on a smooth surface to paper through contact and pressure between the two surfaces.

Frottage is the mark of a texture that is created by simply rubbing the paper with a dry medium.

Frottage on a textured surface made with pencil and charcoal rubbed on a sheet of paper.

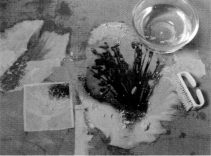

Transferring photocopies. *Apply a thin coat of acrylic gel, then adhere the photocopy to the damp gel. The next day, remove the photocopy paper with water and a brush.*

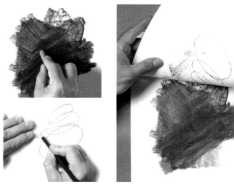

Wax monotype. *Paint a smooth surface with wax pastel crayons that are slightly dampened with thinner or turpentine. Then place a sheet of paper over the painted surface and draw on it with a pencil or with hand pressure. Upon removing the paper the pencil strokes appear as colored lines and the rubbed areas as textured shading.*

MIXED MEDIA

Combining media is the norm in drawing because the effects of each one enrich those of the others.

Combining dry media

Most dry media can be mixed and combined, but the drier ones should be applied before the oily ones. For example, vine charcoal, which is very dry, should go under graphite, which is greasier, and dry pastel should be applied underneath chalk and wax crayon. You can apply a fixative between the layers to help the materials adhere better.

Sgraffito over dry pastel and dry pastel over sgraffito.

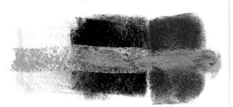

Oil pastel over sgraffito, charcoal, and dry pastel.

Combining dry and wet media

Mixing wet and dry media is perfectly normal in drawing. Artist's inks and pencil, graphite or markers on gouache or colored ink are some examples. However, water-based media do not work over oil-based media (for example, ink over wax crayon), although this incompatibility can create a path to interesting textural results.

Combining wet media

Since the wet drawing media are water-based, they are very easy to combine. You only need to take the transparency of each medium into account.

India ink over gouache.

India ink washed over gouache.

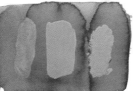

Gouache over colored inks.

Lines of graphite, charcoal, dry pastel, and oil pastel over gouache and ink.

Ink over dry media.

PREPARING BACKGROUNDS

It is not necessary to settle for the supports just as they come from the store. You can alter them to give them more personality.

Textures and primers

To create backgrounds with a certain visual effect and to sensitize the surfaces so that something is already happening before drawing begins, turn to coloring techniques that are seemingly accidental, such as spattering and streaking, or allowing ink to flow freely on puddles of water. You can also apply texture to the support using acrylic gels or relief pastes that can be painted over to create interesting and accidental gradations. To work on a glossy or very smooth surface with a very dry or a water-based medium, first prime the surface with an absorbent acrylic to create a certain amount of required porosity. Collage can be used as a background for drawing and also during the process; a piece of glued paper or cardboard will act as an area of color or texture.

Background with textured paint and artist's ink.

Background primed with absorbent acrylic on glossy paper. This base permits the use of very dry media or washes.

Background textured with washes, bleached spots, and spattering.

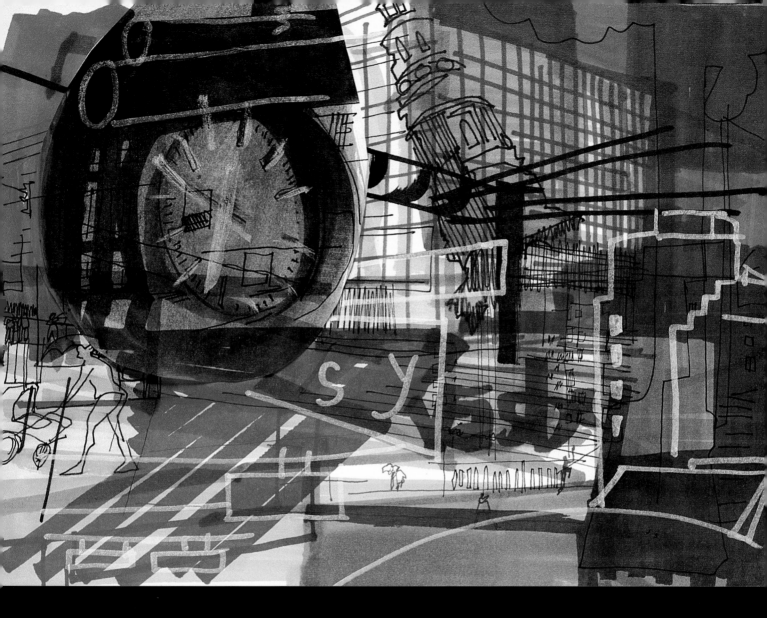

Creative Approaches

01 Line and space
Creative approach

Juliao Sarmento,
Laura y Alice (9), 1994.
Private collection.

Line drawing is the simplest and purest form of expression with which we can express deep emotions. With a simple and poetic line, the Portuguese artist Juliao Sarmento (born in 1948) brings us a world full of lyricism and sensibility. He is one of the greatest proponents of international contemporary painting. Following completion of his education in Lisbon and after a period as a multidisciplinary artist, during which he favored the most conceptual aspects of art, his work evolved into a creative universe with personal pictorial imagery. His early work was somewhat reminiscent of the *Bad Painting* movement of the 1980s, but it became more radical and austere with time as he moved away from the previous inclusion of writings and photographs in his paintings. In the 1990s Sarmento created a series of paintings that are popularly known as the "White Paintings." In them we can see an increase of density, sensuality, and tension. The line drawing takes center stage in the construction of the work and the artist depicts the essential forms with simple gestures. For example, if he wants to draw a woman unbuttoning her dress he draws only that part and leaves out the rest. In search for the purest forms he omits parts of the bodies he is depicting, which in turn emphasizes the emptiness of the pictorial space. His paintings depict an intuitive or dream-like drama, but they are never explicit. The omissions and the incomplete forms convey eroticism and mystery while intensifying with the narrative disconnect of his drawings. He often resorts to the representation of the female body, not in an exuberant way, but rather in an absent and melancholic manner. In *Laura y Alice (9)* the enigmatic figures faintly break into the pictorial space, creating a false sense of repose that keeps the viewer waiting for a dramatic scene to unfold.

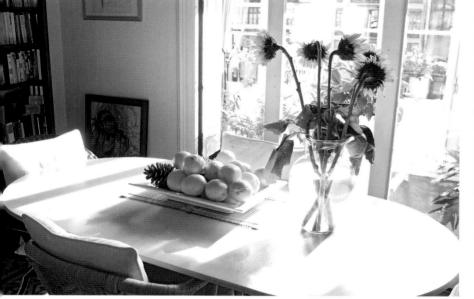

Discovering the poetry of line and space in a pencil drawing

The pencil is a direct and simple medium that is ideal for small and simple drawings. In addition, the different degrees of hardness of the lead make it possible to draw different types of lines. In this project, Gemma Guasch used an interior scene as the model and employed different leads to represent, on white drawing paper, the essential parts of each fragment selected. She has juxtaposed different spatial elements and differentiated them by simply changing the pencil. Here, her main goal is to heighten the empty space and to show the minimum of elements with a broken line.

❝*It is sufficient to offer just what is absolutely necessary to identify what is intended. Only that is needed … For me, what is important every time is to see, not the detail, but its absence.*❞

Juliao Sarmento, excerpt from an interview with Bernardo Pinto de Almedia for the magazine *Lápiz*, 2000.

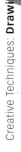

Creative Techniques: **Drawing**

Step-by-step creation

1. The table and the window are drawn on white paper with broken lines. An HB pencil is used because its medium-hardness makes for a well-balanced line. To heighten the empty spaces, the placement of the model represented on the paper is carefully studied.

2. The flowers located on top of the table are sketched on the upper part of the paper. To do this, a 3H pencil, which creates wider lines with a lighter gray tone, is used. Only the flowers are drawn, without the vase or the table. This detaches them from the context, as if they were a gift or a wish.

3. Both approaches have divided the drawing in two: the table and the flowers. Drawing continues without breaking this dichotomy. The HB pencil is used to draw only the flower bouquet. We do not want to break up the image, but to reinforce it. Drawing continues for the bouquet, repeating parts of the flowers and the leaves, but changing their position. By juxtaposing lines made with two types of leads, two different shades are created on the line.

4. Next, new lines for the dining room are drawn with a 3H pencil, creating a harder line along the bottom part. The two fragments are connected by continually using the selected pencils. Prolonging the line of the motif is reminiscent of the space created in a mirror.

5. Before the last lines are drawn, we must reflect and evaluate the empty space created between the two drawn fragments. We do not draw more things from the interior or introduce different pencils. A few broken lines are drawn with the 3H pencil, which give the drawing an abstract feeling. This creates a new pictorial space, one that is represented on paper with fragmented lines that provide an original perspective.

The different techniques one can use for working a space by breaking up its parts are endless. In this project, the artist experiments combining line drawing with fractured interiors to create the illusion of a new dimensional space. Pencils and inks are the media chosen, thanks to their simplicity and austerity. This gallery presents an array of elegant and poetic works.

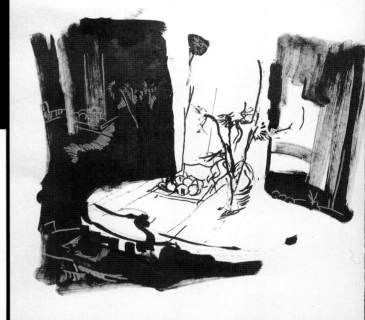

This drawing was made with India ink and pencil. The ink makes it possible to create spaces that are completely black, on top of which lines have been drawn with white pencils. The spatial composition is more traditional because the table has been placed visually in the center. The contrast between the black and white makes this an elegant drawing that is easy to represent.

On a sheet of drawing paper, sections of the interior are drawn with different leads—8B and 4H. The soft pencil makes black lines while the hard pencil makes gray lines, which visually separates the drawings. In the center of the paper both pencils are alternated and fragments of the interior are drawn in different scales. Drawing is done on the lower part of the paper. Leaving part of the paper blank heightens the emotional impact of the empty space.

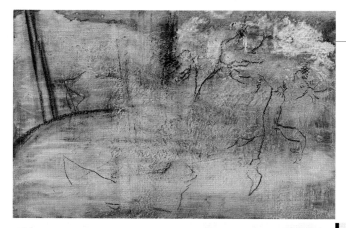

A piece of plywood primed with gesso is covered with black India ink. Before the ink dries, a wash is made with water. The result of this wash is a warm background full of texture similar to those of Juliao Sarmento. The base is worked with compressed charcoal that was later protected with glossy shellac. The feeling of texture is wrapped around the lines, which are difficult to make out: this is the most complex and ambiguous—and even painterly—result of the gallery.

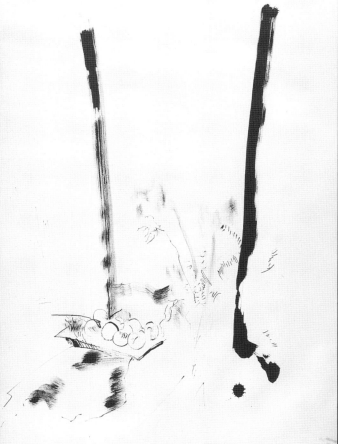

This minimal and fragmented drawing of a section of the space has a more radical impact. The lines were drawn with black India ink and a dry brush. The most direct and blurry shades of the various lines were created by dragging the dry brush through the still wet ink. This drawing contains only the essentials needed for representation.

A simple drawing, minimal and basic, is created with two pencils: HB and 2H. The difference between organic and straight lines helps instill some poetic charge to the different values of the lines in this drawing. The empty space stands out and dominates the paper, allowing us to enjoy a piece where the essential describes everything.

01 Window

New
approaches

Another view Using pencils and inks in black and white can emphasize the austerity and clarity of a drawing. The absence of color has been the approach for this entire project. Gemma Guasch offers another view by painting the background with color and drawing the lines with white pencil. The chosen support is a sheet of plywood covered completely with red aniline dye. Red is a very vibrant and expansive color that intensifies the effect of energy and puts the viewer in an empty space that is perceived as opposite to white. The white lines emphasize the expressive force of the red and create a subtle and elegant contrast.

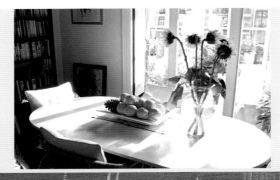

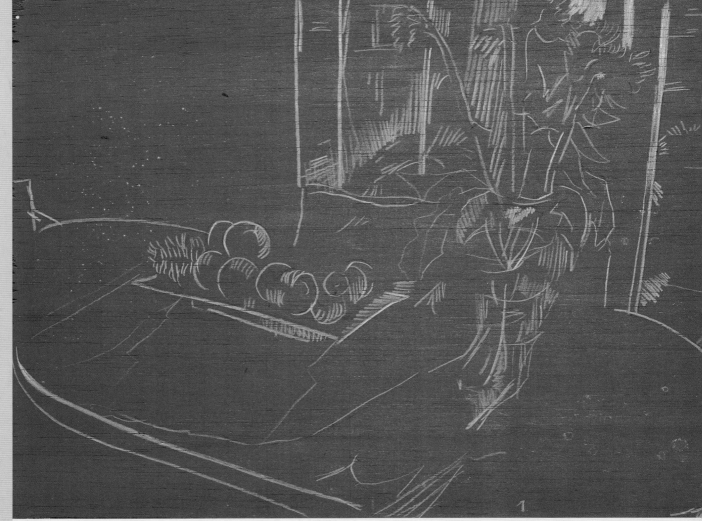

Another model To experiment with a completely different model, Gemma Guasch has chosen a part of the human body: the neck. The anatomical possibilities offered by the torsion of the neck can be used to create a drawing with organic lines. The tension of the muscles beneath the skin inspires softly modeled forms. The drawing is done on white drawing paper using two pencils: HB and 3H. The final result is clean and clear thanks to the medium chosen and the direct and simple lines with which the drawing was executed.

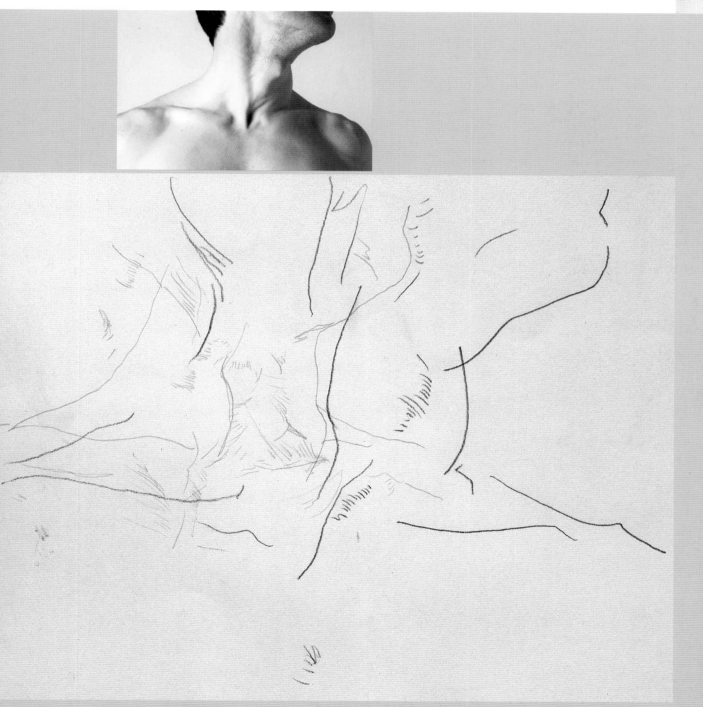

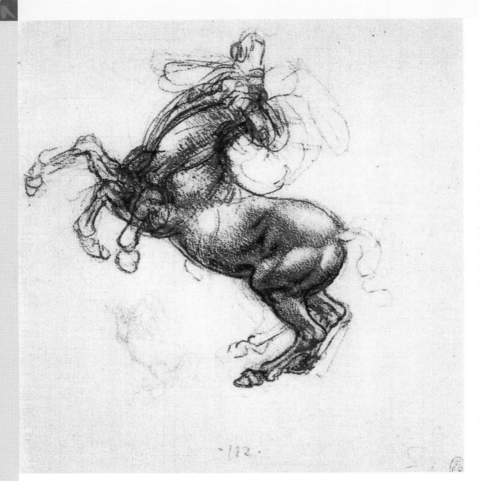

Leonardo da Vinci,
Rearing Horse, 1483–1498.
Gabinetto di Stampe e Disegni
(Florence, Italy).

The word "drawing" is naturally associated with the idea of representation. For most people drawing means, primarily, the graphic illustration of the visual reality of one's surroundings or of the ideas that one has in mind. Einstein said, *"If you cannot draw it, it means that you do not understand it."* One artist who developed this basic idea of drawing to the fullest was Leonardo da Vinci (1452–1519), an artist who lived during the Renaissance period and is known worldwide for paintings and drawings, including the *Mona Lisa*, and *The Vitruvian Man*. In addition to art, Da Vinci produced studies on physics, music, and perspective, and invented, among many other things, the compass, the deep diving suit, and the pasta-making machine. For all this creative activity he always resorted to drawings, using them as the basic language to explore nature and to illustrate his creations. His drawings were clearly explicit, but they were also shrouded in mystery. They demonstrate an acute sense of observation, a great esthetic sensibility, and an incessant search for beauty. Da Vinci demonstrated that art and science are not at odds, but are born from the same inquisitive spirit. Drawings like the *Rearing Horse*, done with red chalk and pencil on a small piece of paper, are a good example of his proclamation that, *"Nature, benevolent, provides in such way that everywhere you find something to learn."*

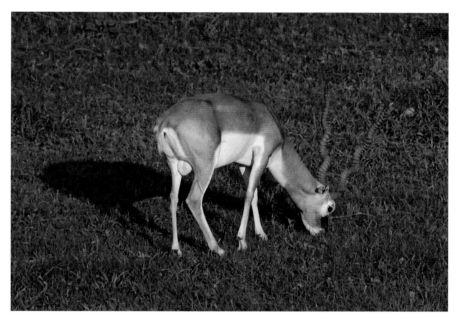

Drawing animals with expressive lines in colored chalk

Dry techniques are ideal for drawing because the hand can exert more control on the support due to the rigidity of the applicator. Chalk is the most commonly used medium by artists when drawing from nature. In this project, Josep Asunción used chalk to create a series of animal sketches. In addition to working with a wide assortment of chalks, the artist has used different colors for the support. The main goal here is to experiment with the line to represent contours, masses, and textures, and to do so without any restraints. Work is done freely and liberally, attempting both a faithful representation of what is being observed and the plastic possibilities of the subject matter.

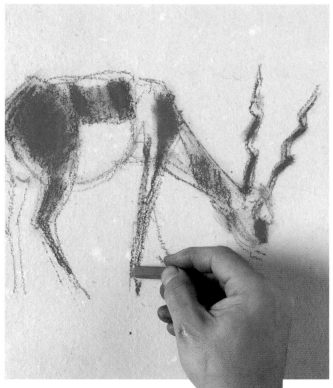

Drawing is, primarily, to look with the eyes, to observe, to discover. Drawing is learning how to see…"

Le Corbusier

Step-by-step creation

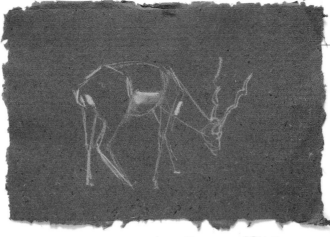

1. A gazelle is sketched on paper made by hand from recycled cotton clothing. Since the dominant color is blue, warm colored chalks were chosen. First, the silhouette of the animal is laid out with light yellow lines. After planning the proportions correctly, more pressure is applied to the chalk in some areas so they stand out against the background.

2. The gazelle has two tones of light on its fur. The lighter tones are on the abdomen, inside of the neck, and in the details of the limbs; darker tones are on the rest of the body. The initial touches of yellow color are applied in the areas of light, and then the drawing of red lines continues for the dark areas. This constructs the massive areas of the animal, as we are not only attempting loose line work, but also volume.

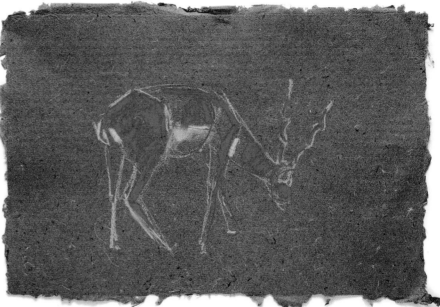

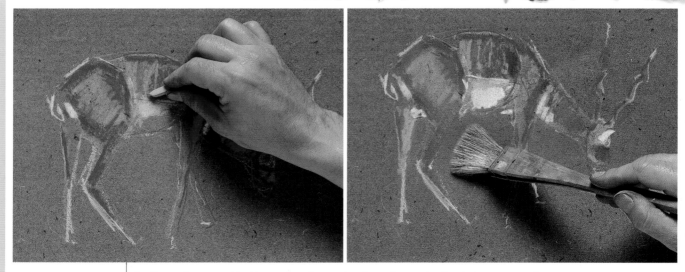

3. New colors are added to create volume—touches of green for the darker areas and pink over red to create lights. Two techniques that are unique to chalk are combined: crosshatching, which emphasizes the energy of the line, and blending with a brush, which creates atmosphere and softness.

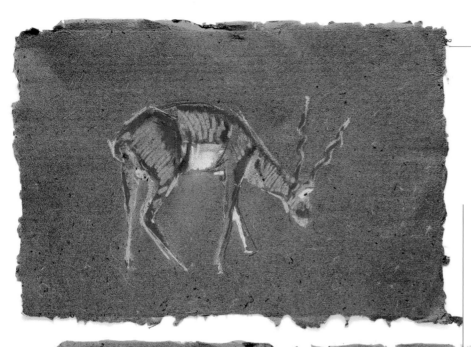

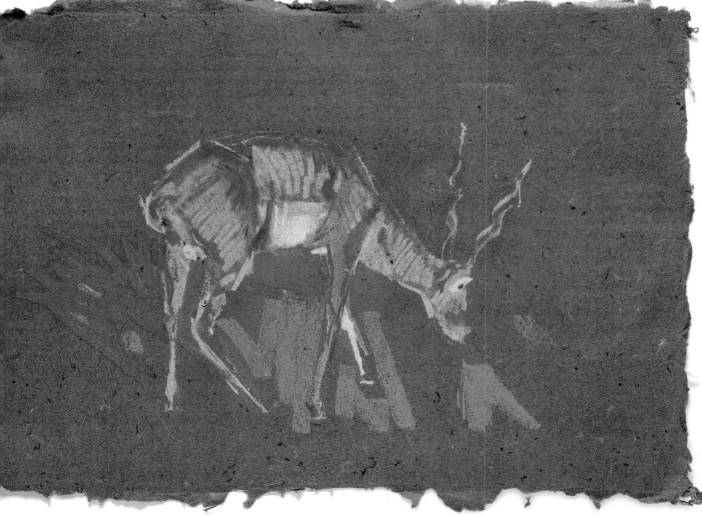

4. Next, new orange hatch lines are applied to chromatically connect the two areas of light on the fur—yellow and red. Elsewhere, a great feeling of texture is created. There is no blending; the colors underneath show through the gaps on the hatch lines.

5. Notice how the blue color of the paper comes through in small areas of the animal's body; this keeps the work fresh and helps integrate the figure and the background. Finally, the study is completed by highlighting that figure–background integration with wide, loose, vigorous lines, paying attention to the surrounding light and the shadow of the gazelle projected on the grass.

Creative Techniques: **Drawing**

Few things are more stimulating than a sketching session at a zoo or a farm, because every animal inspires the artist in a different way. For this project, the artist wanted to experiment with chalks on several animals encountered in his outings. This gallery shows several results.

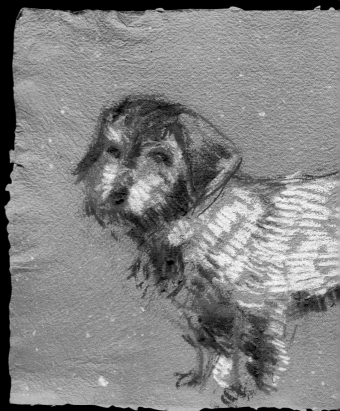

This is a very different sketch. The artist chose not to represent the entire animal, but only the head and the fur, using an original photographic layout of a herd of sheep native to his region. To represent the hair in a creative way he has combined soft areas of color that allow the texture of the paper to show through, with curved lines and soft blends.

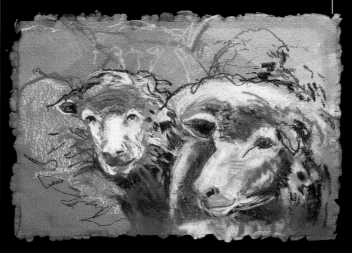

For this picture of a monkey and her baby in the public park of Ágra, India, the artist had to execute the piece with quick strokes, pressing the chalk more or less according to the intensity desired for the different fur areas of the monkey. The color range combines yellow and orange tones, with no other contrast than black and white.

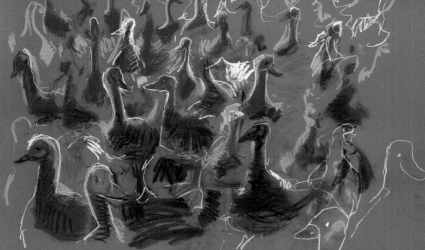

An unusual scene of a group of geese on a farm in the French region of Périgord. The challenge was to represent many animals without falling into boring repetitiveness. To make the drawing more lively, the artist has combined blended areas with contour lines, sometimes overlapping the animals and other times not.

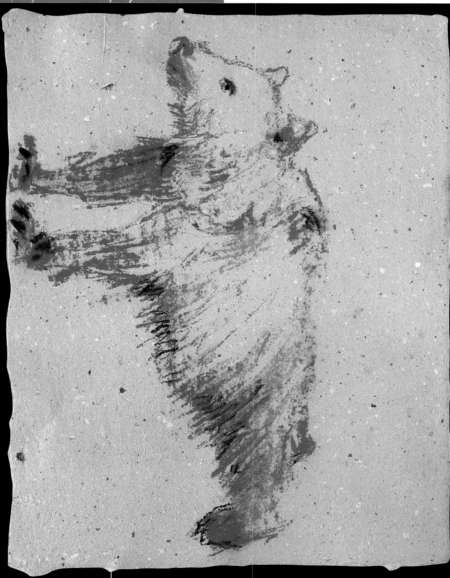

The little dog is the artist's family pet. This time he has used the color of the support as the base color for the animal. Lines of dark green appear in the shadow of the fur, while white lines in the areas of light let the color of the paper show through. The lines follow the same direction as the fur, and go very well with the red lines of the contour, adding chromatic energy to the piece.

A quick sketch of a brown bear from the Barcelona Zoo is drawn with red and violet chalks on yellow-green recycled paper to highlight the complementary colors. The texture of the fur has been achieved with long unblended strokes to re-create the feeling of the hair's coarseness.

Descriptive gesture

Other views Chalks make it possible to emphasize many aspects of line drawing, broken-up colors, flat colors, crosshatching, atmosphere, and color brilliancy. Using the same model of the Indian gazelle that we have seen before, Josep Asunción has created two variations: one very linear, without any atmospheric effects or shading using clean and pure lines; the other completely atmospheric, executed with heavy shading. In both cases he has made great use of the texture and the color of the paper to create a wavy effect on the first one and a heavy impasto on the second.

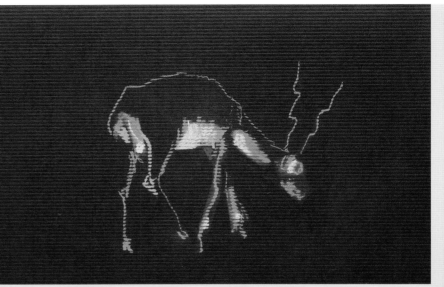

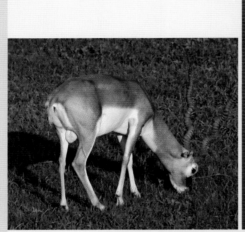

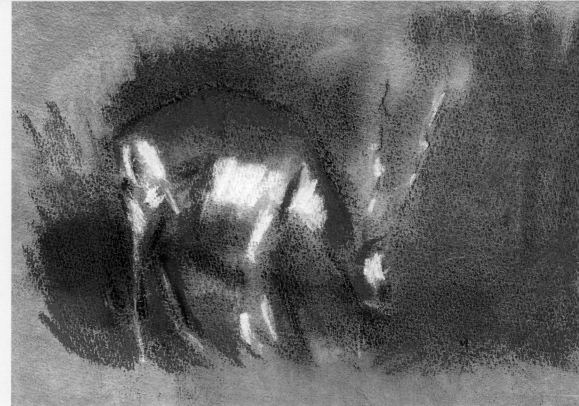

Creative Techniques: **Drawing**

Other models Chalks are frequently used to draw moving figures because they leave a porous mark on the paper that can be combined with dynamic lines and soft and airy shading. To experiment with a completely different model from animals, Josep Asunción has chosen the study of a sports theme that conveys speed in combination with mass and air. The scene of a motorcycle passing in front of the spectator on a racetrack is very suggestive thanks to the play of masses and colors blurred out by the effect of the speed.

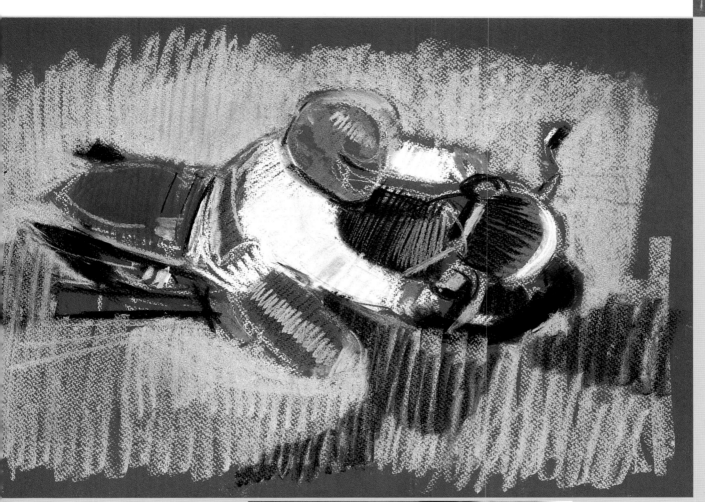

03 Color and shading
Creative approach

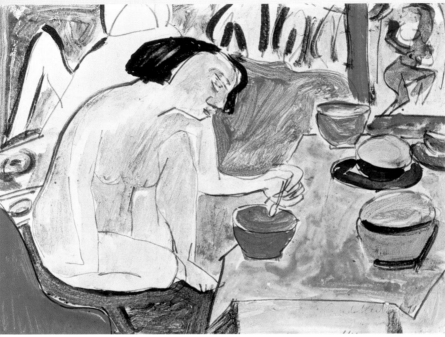

Erich Heckel,
Kneeling Figure in the Studio,
1911. Private collection.

In Germany at the beginning of the twentieth century two young students with revolutionary ideas and aspirations founded a group called "Die Brücke" (The Bridge). They promoted graphic art, drawing, and painting equally. The artists worked intensely in their studios, producing hundreds of art pieces on a daily basis. The studio became a home for the models and painters; the hours they spent together there became a source of inspiration and contentment that could be perceived in the freedom and intensity of their pieces. Using the work of Van Gogh as a model, their goal was to create highly expressive art with simplified line structures, and large compositions in pure colors. Erich Heckel (1883–1970) was one of the group's most important members. His idealistic concept of friendship among artists kept the group together for six years. Heckel did not try to capture the instant, but rather to speak about humans and their aspirations. For him, personal relationships were everything; without them he was lost. His aim was simplicity. To achieve this he simplified and limited form and color, with results like the drawing *Kneeling Figure in the Studio*, done with clear colors and precise lines executed in gouache and pencil. His later work conveyed his emotive humanity with an expression devoid of aggression and characterized by balance and inner contentment.

Expressing vivid colors in a gouache drawing

A simple still life represented with just a few elements is ideal for showcasing the chromatic power of complementary colors. The artist, Gemma Guasch, chose to use gouache to create a drawing that is fresh and full of vitality. This medium has helped her in two ways: first, the luminosity of the pigments provides chromatic richness to the drawing, and second, its dense and pasty texture aids in the construction of the drawing through shading. Only a flat narrow brush is used to apply the gouache. To finish, thin lines drawn with colored chalk are used to add definition and structure.

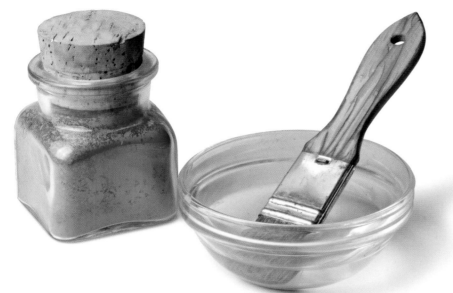

“ *It is not possible to separate drawing and color… Drawing is a painting executed with few resources.*”

Henri Matisse, *Écrits et propos sur l'art.*

Step-by-step creation

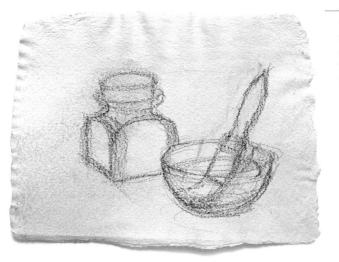

1. On a delicate sheet of handmade paper, the still life drawing is laid out with a stick of soft graphite (3B). The volumes are proportioned and defined by applying only slight pressure to avoid leaving marks on the paper.

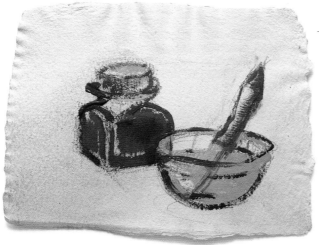

2. Next, the still life is painted with cyan blue gouache applied straight for the darker outlines; the same color is diluted with white for the lighter tones. The objects are not covered completely to maximize their transparency. The brushstrokes are very dense and done without too much water. This creates a blurry effect that prevents the objects from looking opaque.

3. The background is painted in a complementary color, orange, and is defined with two tones that cover the surrounding space. The background is left to dry—it is very important that the orange tones not mix at all with the blue. If they do they will turn gray and lose their luminosity. The areas of the still life that we want to continue painting are reinforced with white.

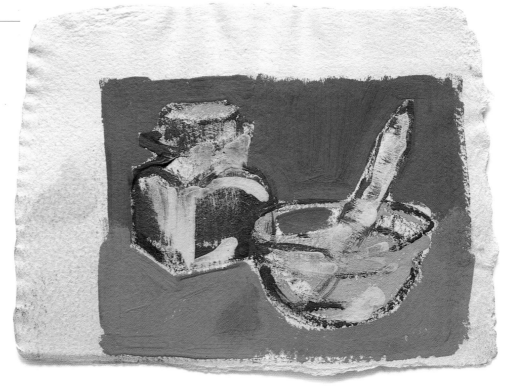

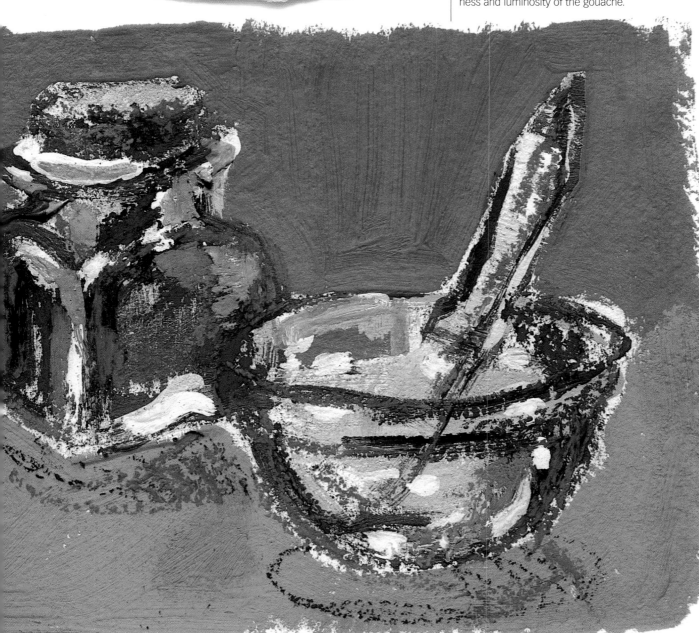

4. The insides of the objects are painted with reds, blues, and whites. The contrast of the three colors reinforces the volumes. The reds and blues define the darker areas, while the white highlights the light and luminosity. Next, colored chalks are used to slightly define the projections of the shadows; reds and blues are used to contrast the colors and make the orange of the background stand out.

5. To finish, the harshness of the white paint that was applied directly to the still life is softened using the same orange of the background reduced with white. This minimizes the harshness of the color contrast, gives the theme a poetic feeling, and maintains the inherent freshness and luminosity of the gouache.

Here the artist has focused on the power and contrast of complementary tones to express herself through the use of color. She has also changed the colors of the handmade papers to enrich the chromatic vibrancy.

The support chosen for this gouache is a double-sided handmade paper. Harmony has been created with the use of complementary colors: dark green and carmine red. The thick and pasty brushstroke that forms the objects creates character and opacity. Finally, a few pink touches of gouache and colored chalks create light and clarity.

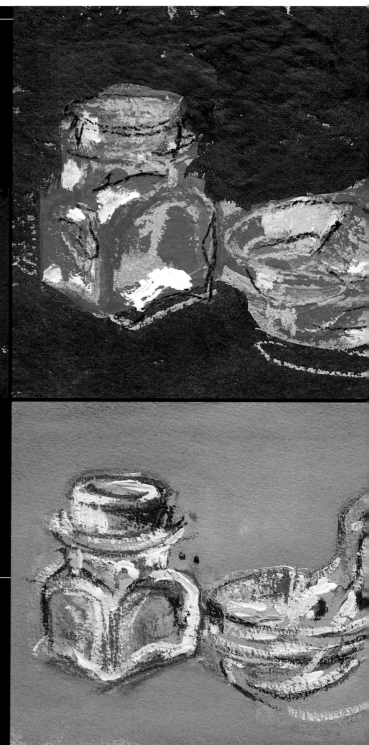

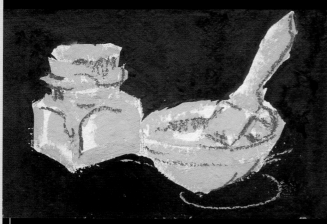

This drawing employs the simplicity of two complementary colors: purple violet and green yellow. A few unpainted areas of the paper are visible, giving the subject a light and transparent feeling. Using chalk the artist has loosely defined the still life drawing. The purple-violet chalk is alternated with the greenish yellow on the objects to increase the play of colors. On the background, a simple, thin greenish yellow line defines the projections of the shadows and makes the purple-violet tone stand out clearly.

The motif has been drawn on blue handmade paper. The artist has chosen a light cerulean blue for the background and orange-yellow for the objects to avoid maximizing the contrast against the color of the paper. The objects have been worked with dry strokes of different white and yellow tones, contrasted with blue and lilac chalks. The background, which has been painted with a wet brush, provides a soft and flat effect that contrasts with the richness of the still life's texture.

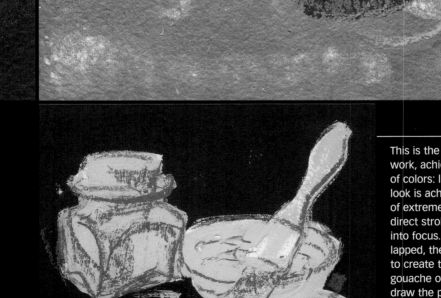

This minimalist work on a two-color handmade paper is already very suggestive. The double color of the paper comes through between the lines of the minimal green-grass–colored strokes that define the still life. Over the green, the luminosity of a few orange chalk lines define the points of light, which contrast with the color of the paper.

This is the most striking and radical work, achieved with maximum polarity of colors: lilac and yellow. This striking look is achieved through the application of extreme colors and the quick and direct strokes used to bring the drawing into focus. The media have been over-lapped, the violet chalk over the yellow to create the volumes, and yellow gouache over the lilac background to draw the projection of the shadows.

03 Window

New
approaches

Another view Here the artist has varied the technique to achieve a very different view. Devoid of light, the still life acquires a weathered impression. The still life is painted with gouache, following the same chromatic idea of the complementary colors, but this time with magenta and greens. After verifying that the gouache is completely dry, the artist painted over with India ink. She let this dry a little and then made a wash with water. This technique helps recover the gouache tones partially, while preserving the weathered and muddy effect. Finally, once the paint has dried, the forms of the objects are redefined with colored chalks to prevent the drawing from looking too undefined and blurry.

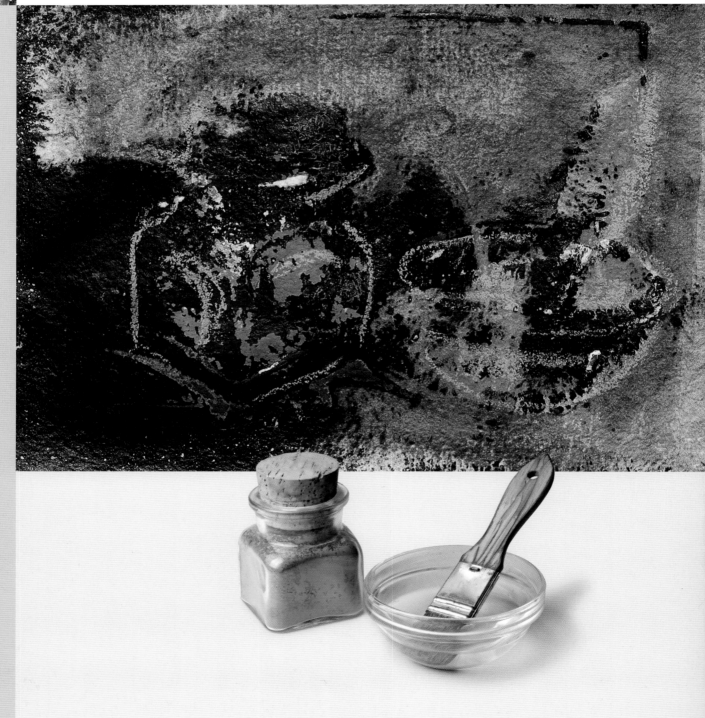

Another model To vary the theme, the artist has changed the genre and has selected a scene with vegetation as a model. The natural expressive character of the cactus is highlighted by treating it with the strong colors of gouache and chalk. The complementary colors chosen hold enough power in themselves to highlight and bring anything to life. The chalk lines, liberally applied, provide luminosity to the dense and creamy texture of the gouache. Gemma Guasch has emphasized color contrast to the maximum in this drawing, without losing the luminous energy provided by the paint.

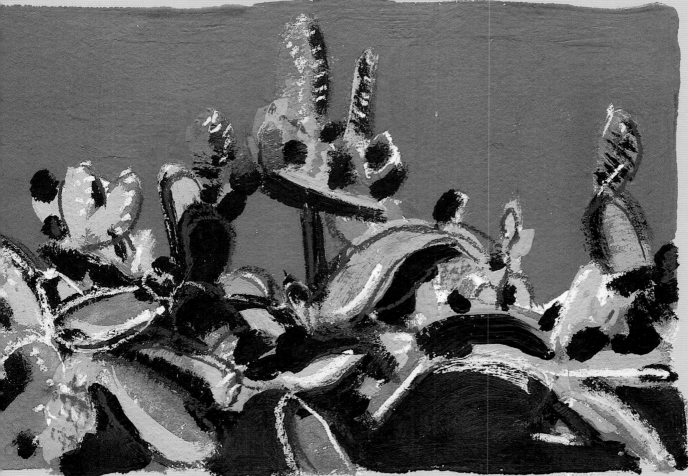

04 Chiaroscuro
Creative approach

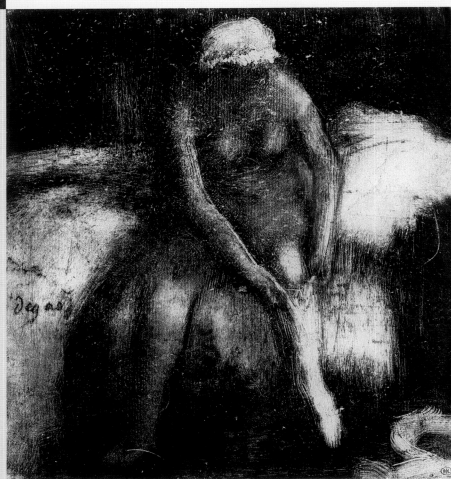

Edgar Degas,
Seated Woman Putting on Her Stocking,
c. 1885. Musée du Louvre (Paris, France).

From the first pencil, charcoal, and chalk or sanguine drawings of the Renaissance, artists have felt a special desire to represent the human body, to understand its anatomy, and to express its power and sensuality. For centuries, drawing has been the ideal medium for this task. Inscribed in that tradition, the Impressionist painter Edgar Degas (1834–1917) demonstrated an extraordinary ability to create and innovate without renouncing tradition. He admired Ingres, the academic artist of drawing par excellence, and believed wholeheartedly in the importance of drawing that Ingres had so often predicated. Despite having a warm and friendly personality, Degas often went through periods of solitude and isolation. During the 1880s, a series of eye problems made him fear possible blindness; sunlight bothered him tremendously and he was forced to work in the dark. In some letters from this period he expressed his great solitude. During those years he tried the theme of women in the bathroom, as a link between tradition and innovation. *Seated Woman Putting on Her Stocking* expresses both the dark and tenebrous environment in which he lived due to his eye problems, and his enormous sensibility and freedom of movement. In Paris, in the same year in which he drew this piece, Degas exhibited a large number of pastels of women in the bathroom of which he said, "… a couple of centuries ago I would be painting Susana in the Bathroom, today on the other hand, I paint *Woman in a Tub…*"

Creating light and shadow by drawing and erasing

This creative project, undertaken by Josep Asunción, consists of a series of chiaroscuros created with charcoal on paper with a non-academic emphasis on the human figure. Rather than beginning with the blocking in and the proportioning of the contour lines, followed by the shading of the highlights on the paper, he begins by covering the paper with charcoal and extracting the areas of light. Work is done by shading and erasing the highlighted areas of the model and drawing with a stick of charcoal as needed to restore dark areas or to reinforce details.

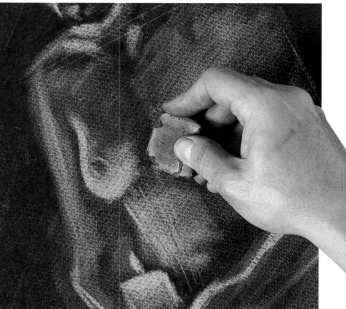

❝*Form is not in the contours; it is inside of them. Shading does not add to the contour but rather creates it. The reflections on the shadows of the contour are not worthy of the majesty of art.*
We must dominate the internal structure if we wish to express its surfaces. I know the muscles, they are my friends; but I have forgotten their names.❞

Edgar Degas. *Diary of Daniel Halévy,* January 22, 1981.

Step-by-step creation

1, 2. To make a suggestive chiaroscuro yellow Canson paper is chosen for the background, rather than classic white paper. The entire surface of the paper is colored with a stick of charcoal, blending the lines to create an even and atmospheric area of color that will not be fixed. This allows the artist to continue drawing lines while still erasing.

3. A cotton rag is used to gently erase the areas of light on the model. Work is done carefully to avoid going beyond each area, which results in a loss of the drawing.

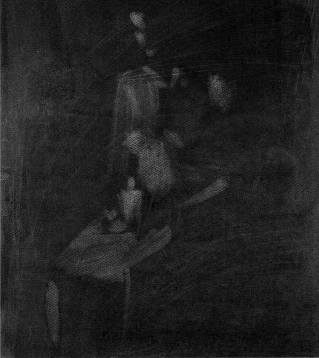

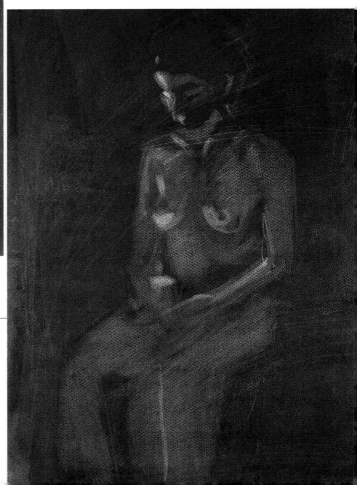

4. Modeling of the body is finished with the rag and reinforcement of the highlights with the kneaded eraser. More precise lines are drawn for critical details like those of the face.

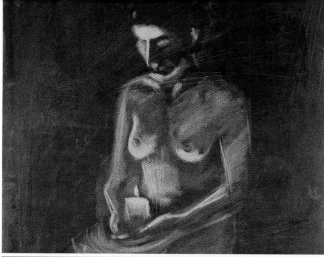

5. Little by little areas of light are added to soften the model. This is done by wiping with a rag and the kneaded eraser. The breasts, the face, and the arms are defined by intensifying the highlights to achieve great chiaroscuro contrast.

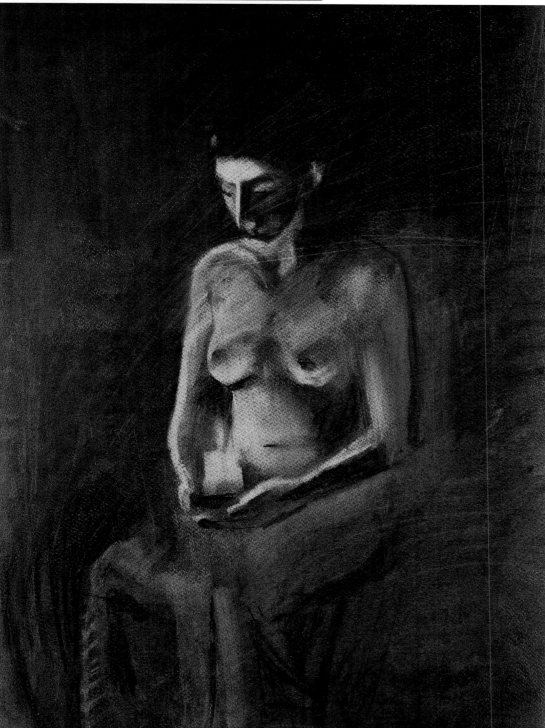

6. To finish, contrasts are softened by modeling with the rag and charcoal is used to restore the grays. Contour lines in the dark areas, such as the arms and the modeling of the legs, are defined. The final result is a rich combination of shadows and lines.

04 Gallery
Other versions

In a chiaroscuro, light forms the image, not the lines or the color. The images in this gallery show that by modifying the way that light is applied—either by adding charcoal or by removing it with erasing—it is possible to achieve very different effects, some more gestural and others more airy. The color of the paper has been varied to show how the charcoal reacts differently according to the color of the paper with which it interacts.

The Chiaroscuro is modeled with a stick of compressed charcoal on gray paper. In this instance, the background around the figure has been shaded to maximize the light of the paper.

This chiaroscuro is the most evanescent of the gallery. The ambiguous effect of the scene was created by using a rag after the image had been constructed. A general wiping from top to bottom blurs the drawing and creates atmosphere. This intervention highlights the brown charcoal tone, which is strengthened by the yellow of the background.

The next chiaroscuro project was created on yellow paper darkened with powdered charcoal, which enhances the use of line, rather than shading. Using parallel lines that follow the same inclination, the body is modeled with a hatching effect that is interrupted by thin contour lines created with a pencil eraser.

This example combines drawing and erasing in a very gestural approach, which makes the work very expressive. The red color of the Canson paper contributes greatly to that dynamism, as does the decision to add white with a stick of chalk for the light of the candle.

This chiaroscuro with hatch shading is dynamic and expressionistic. The key to this work lies in knowing how to combine the hatch lines by varying either the inclination, the thickness, or the distance between the parallel lines. Some hatch lines are made with charcoal, and others are done with an eraser.

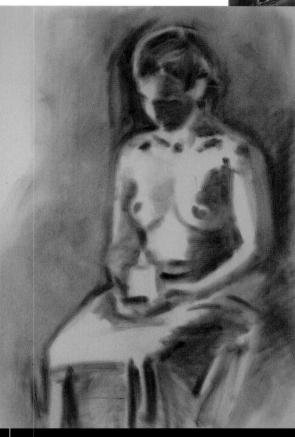

This is the most suggestive drawing of the gallery. It has been done entirely with a cotton ball and charcoal dust on cream paper. While it is impossible to define shading with a cotton ball, it does give very soft and airy results of incredible sensuality.

Creative Techniques: **Drawing**

Another view Through the entire project charcoal has been used to create darkness; either the eraser or a rag creates areas of light as needed. To show a different approach, Josep Asunción has chosen black Canson paper and created chiaroscuro by drawing the light with white chalks and medium and dark grays. Chalk is also a dry medium and responds similarly to charcoal, although it is more radical in terms of the pigmentation. The result is more contrasted with less atmosphere, but truly effective. By avoiding blending, the texture of the paper has been enhanced.

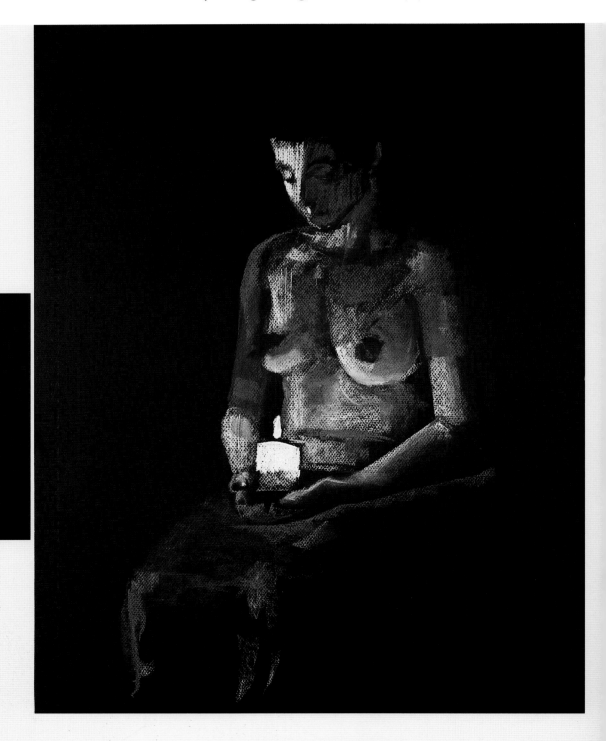

Another model Drapery is a classic subject in chiaroscuro. A simple piece of hanging fabric, like the one chosen by this artist, provides great inspiration. The wrinkles, folds, volumes, and relationships that occur inside the cloth are the true subject. The artist uses two approaches to draw his fabric, one with blended lines and the other with hatch lines.

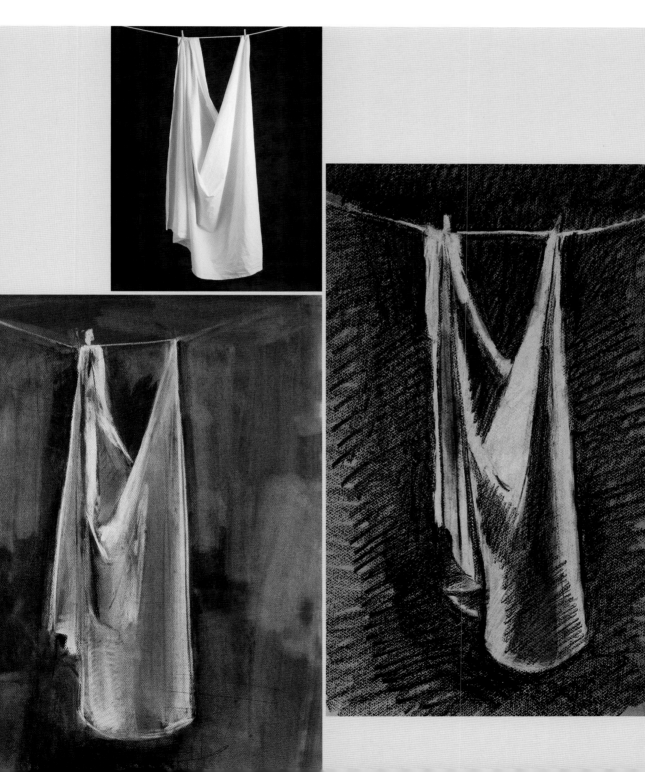

05 Travel sketchbook

Creative approach

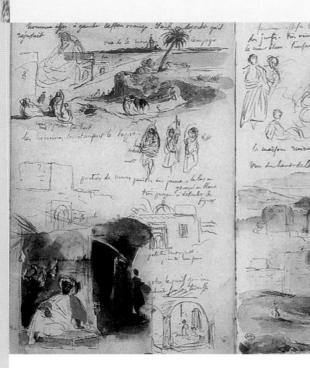

Eugène Delacroix,
Album from Northern Africa and Spain,
1832. Musée du Louvre (Paris, France).

Since ancient times, creative people, scientists, and adventurers have maintained travel journals filled with intimate and personal accounts of their adventures, experiences, and discoveries. Journals were also used by artists like Durero, Turner, Gauguin, Picasso, Barceló, and many others. In 1832, the Romantic painter Eugène Delacroix (1798–1863) traveled throughout Tangier, Mequinez, southern Spain, and Algeria. Romantic artists dreamed of discovering a new world in the Orient that would provide an outlet for their stagnant routines and offer a way to recharge their dormant passions. In that sense, Spain and Northern Africa were for decades the preferred destination of the British and French artists who were in constant search of new and intense emotions. On his trip, Delacroix worked on his famous "travel journal," full of entries and drawings that provided visual inspiration for the rest of his life. The observations of this period highlighted his preference for the study of color and the action of the light in the tones. The impact of the trip is also reflected in the correspondence that he maintained with his friends. *"I am truly in a very interesting country… I fear for my eyes, although the sun is not too strong yet… Amid this vigorous vegetation, I experience similar sensations to those I had during my infancy… I am convinced that I do not reflect but a shadow of it. In this short time, I have lived twenty times more than in a few months in Paris."*

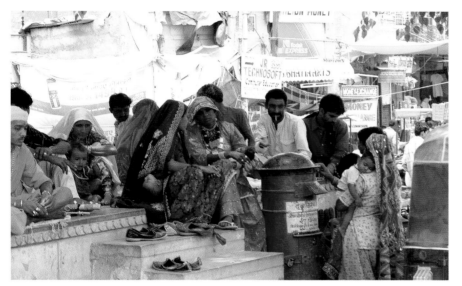

Capturing impressions and experiences with colored pencils

Travelers try to capture impressions of the landscape, the architecture, and the local people with a photo or video camera. In this exercise, Gemma Guasch shares sketches of her travels, drawn with simple colored pencils. This simple and quick medium allows her to capture *in situ* the feeling of the instant, using sketches drawn while on the road. Colored pencils are ideal for this work; if you use soluble pencils, they can be diluted with water to create watercolors.

" Drawing is an inevitable impulse, it is something indispensable, from where you react when you are short of time or when there is something that has caused great impact. It conveys things very well for being so modest."

Antonio López, conversations with Juan José Molina in his house in Madrid, 1997.

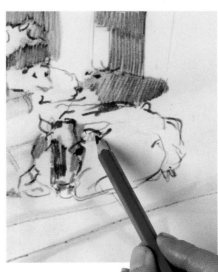

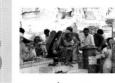

Step-by-step creation

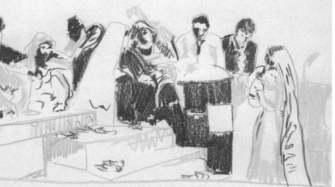

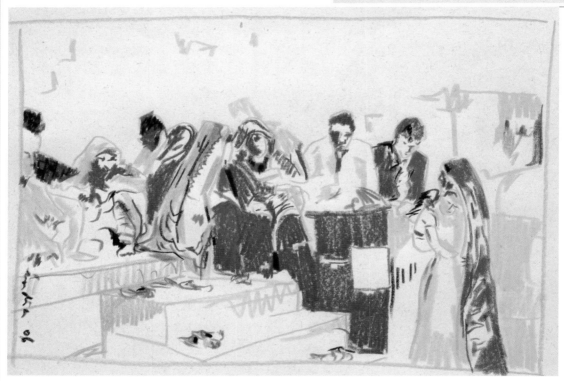

The contours of the people are drawn with a yellow pencil and composed in the space. The masses are enhanced with two colors: red and yellow. The lines for the masses are achieved by applying pressure vigorously and without hesitation on the support. Finally, contrast is added with small, light touches of color that highlight a few details of the theme. Colored pencils, applied with energy and combining bright and contrasted colors, provide great chromatic brilliancy.

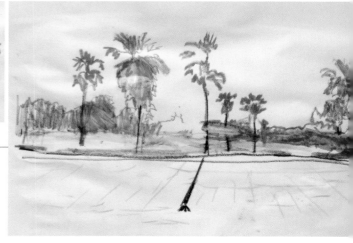

This sketch is done with a wet pencil, which provides diluted and soft watercolor effects. First, the palm trees are planned, taking into account their shapes and sizes and the variety of greens. Then, the space and the projecting shadows are drawn. The length of the central palm tree's shadow is emphasized to establish the position of the sun.

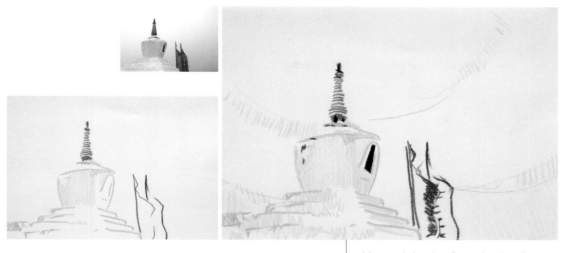

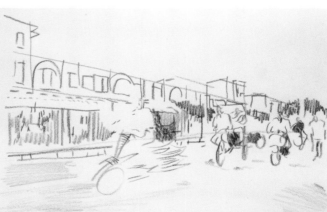

This travel sketch reflects the cleanliness and silence of a Buddhist temple. Only the cupola and part of the flags are drawn, respecting the void and cleanliness of the empty spaces. To finish, a beige tone and small contrasting touches are applied to the flags and the window. Each stroke is diluted to allow the white of the paper to show through.

Light and vigorous strokes convey the dynamics and the life of this moment. The diagonal composition favors this sense of dynamism. Only light pressure is applied to the colored pencil, in order to leave a light impact. To preserve the fleeting effect the theme is reinforced with similar tones and without defining or adding any details. We complete the sketch with a few color touches that convey the chromatic energy of the city.

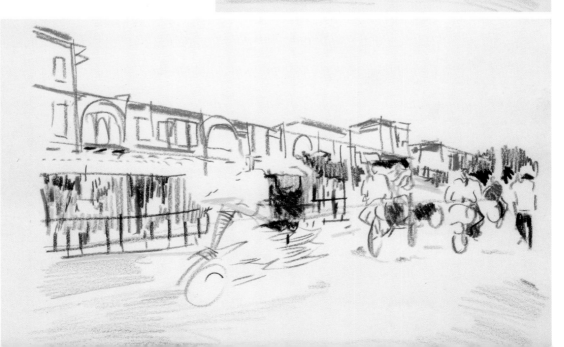

Creative Techniques: **Drawing**

Throughout her trip to India, the artist put together a journal full of sketches that illustrate the experiences of each moment. This gallery highlights several of these sketches, in which different uses of the colored pencils can be seen, according to the chosen background or the working method.

This is a sketch of two female figures wearing exotic dresses and bright colors. The background is represented with small touches that situate the image in the space. Maintaining the white of the background makes the eye focus on the figures; the clean and direct line enhances the medium and gives it character.

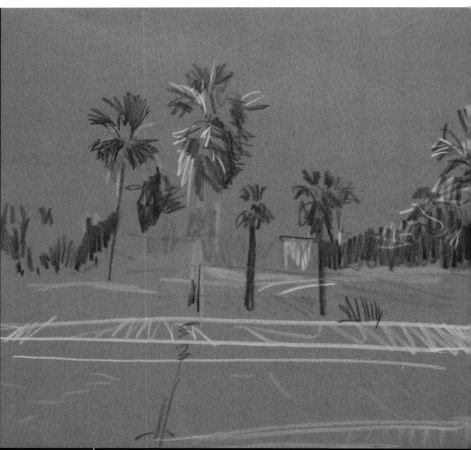

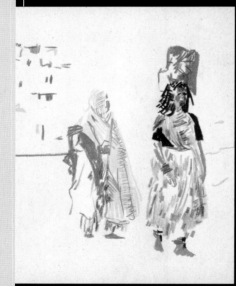

A pink background places the spectator in a space full of life and color. The quick and spontaneous lines of various colors offer a dynamic and lively landscape where the color takes center stage and the line defines the landscape with freshness.

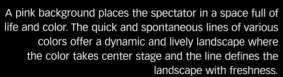

Here is a work scene where the animals substitute for machines to work the fields, providing a glimpse of the methods used by the locals. The colored pencil is dampened with water to reinforce its color. Hatch lines spread through the entire paper, adding to the dynamism of the piece while showing the grid of the rice fields.

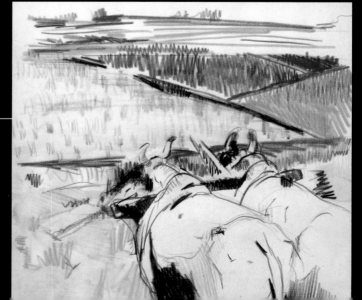

Rickshaws or bicycle taxis, heavily painted and decorated, are typically seen in India. In this sketch we can see the chromatic energy of the bright colors worked confidently and vigorously. The diagonal composition and its finishing help partially define the life and the dynamics of the place.

A monochromatic work of palm trees drawn on wet paper demonstrates the possibilities of colored pencils, which in this instance look more like markers or ink. The forced composition offers a magical and dream-like view of the landscape.

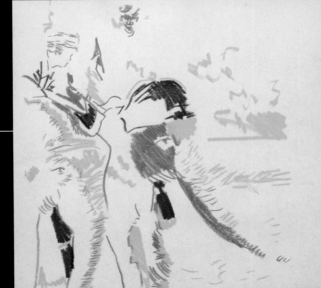

This sketch achieves a magical and exotic note with just a few lines; using color the artist re-creates a few elephants and their porters. The definition of the forms without their contours makes it difficult to see the theme at first sight and forces the viewer to concentrate to complete the form and understand the scene.

05 Window

New approaches

Other views Travel sketches can effectively be made with graphite. Some types of this medium dissolve with water and are very comfortable and easy to take on a trip. Gemma Guasch presents a view of her journey in which color plays no part, demonstrating how a good drawing can be created with a simple gray line. In the first sketch a soft, not well-defined line uses one point perspective to represent streets full of people walking, on bicycles, or in cars. The lack of definition and the unfinished approach capture the moment, without any aim of stopping it. The second space has greater definition. It is a landscape of rice fields she sketched while traveling by train; the lines are more vigorous and defined, conveying different qualities of the gray that wet graphite leaves on paper, depending on the pressure of the lines.

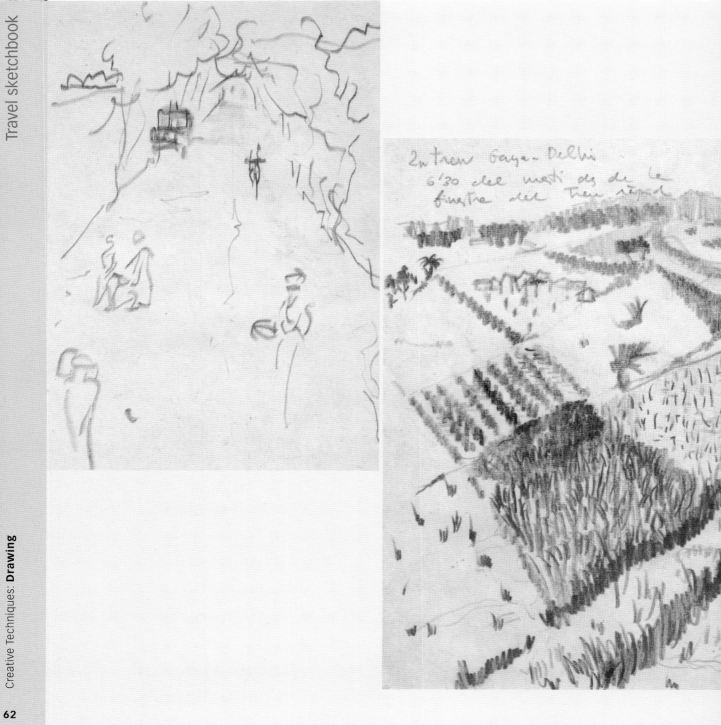

Other models In this instance, the artist sketches a trip to a location more similar to her own: a view of the streets in a rural town of the south of England. The perspective and construction of the houses, as well as the people, differ completely from the subjects of the previous pages. The austerity of the colors, the use of stone, and the gray pavements convey a more austere and less lively use of the colored pencils. In this sketch, Gemma Guasch captures the order and solitude of the street and its inhabitants with well-defined lines that keep the white spaces of the paper in check.

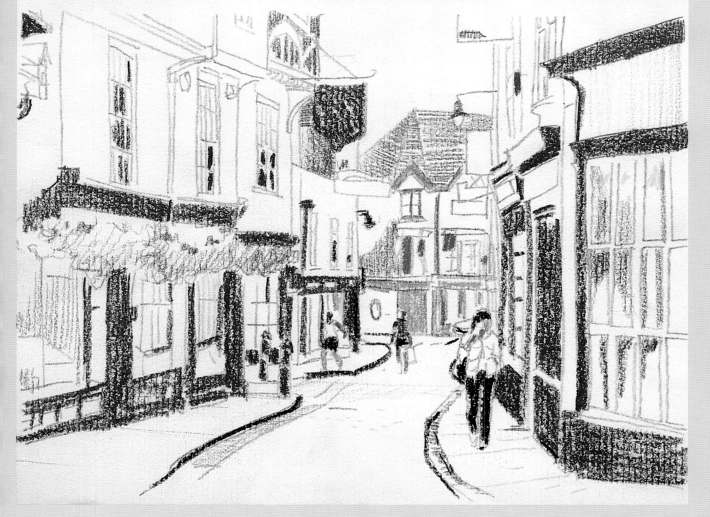

06 Transfers

Creative approaches

Robert Rauschenberg, *Untitled*, 1969. Private collection.

The use of transfers dates back to the 1960s, but it is still a novelty for many artists. Transfers can be done following different methods, but ultimately the goal is to work with photographic images. This brings together technology, drawing, and painting, blending the old with the new. The artist who has researched this formal and conceptual relationship the most is Robert Rauschenberg (1925–2008), one of the first New York artists to establish residence in Soho. In addition to painting, Rauschenberg made deep forays into the art languages of the time. His technique, called "Combines," is the transfer and application of images from woodcuts, serigraphs, photosensitive emulsions, photoprints, cyanotypes, photocopies, and X-rays onto paper or canvas. Through the years he experimented with different transfer mediums, including solvents, glues, impressions, and emulsions. This allowed him to develop another one of his talents, photography. This also provided a source of images for the transfers, and he could work them with dry or wet techniques.

Drawing by combining art with technology

The artistic possibilities of transfers are enormous. They offer an interesting visual aspect that combines the new with the traditional. In this project, Josep Asunción has created a series of drawings by combining photocopy transfers with traditional drawing techniques using pencils, chalks, India ink, and other art inks. The support is linen canvas, which though traditionally used for painting, works very well for drawing if it is properly prepared. To take advantage of its natural coarseness, it may be used unprimed. The base material is a series of black-and-white photocopies of photographs depicting floral details and the fragment of a poem. The latter, for its rhythm and content, reveals the process that ties the artist's thoughts and the drawing together. The memories that arise from it prolong the image even more.

❛*The true drawing is not found in the 'final drawing' but in the strategy that draws the grid that articulates the different strata of drawings that the project is made of. An action that makes it possible to maintain the individuality of each one of them, as a contradictory system of possible reconstructions, and as the key of a differentiated reflection over the identity of that which is represented.*❜

Juan José López Molina

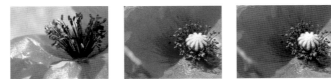

Step-by-step creation

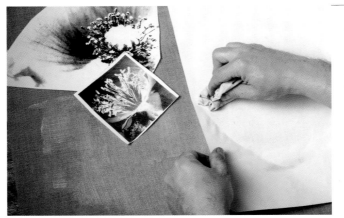

1. The first step in making the transfer is to prepare the support with a thin layer of acrylic gel over which the photocopy will be firmly adhered while the gel is still wet. This technique only works with photocopies, not with digital impressions. In the latter the ink penetrates the fibers of the printed paper and does not transfer.

2. Once the acrylic gel is completely dry, the photocopies are wetted until the paper comes apart. Only the ink of the photocopy remains glued to the support by the gel. A brush can be used to remove the paper from the support. If needed, this procedure can be repeated to finish removing the fiber from the support, this time massaging the wet support gently with the fingers.

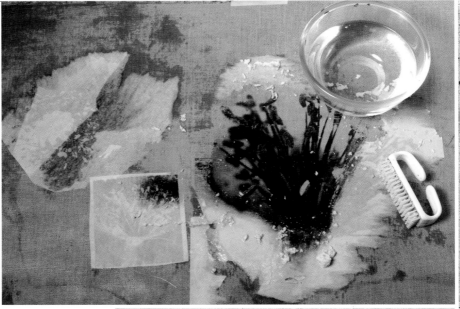

3. Once the paper is completely removed and the support is dry, a base exists on which to continue drawing with traditional media. The end result is as close as possible to paper. It will absorb the inks well, and the pencil or pastel lines adhere perfectly. If desired, a second layer of absorbent ground can be applied. This step is not needed if you like the effects created by the initial layer of gel.

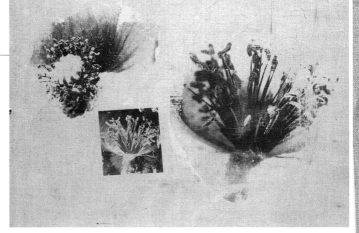

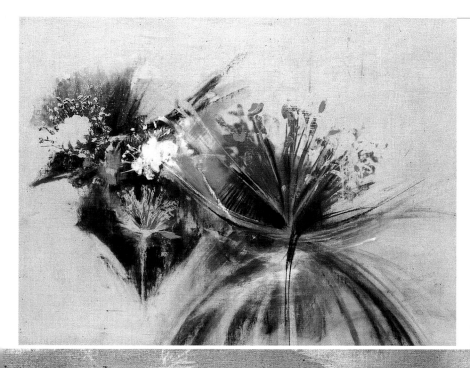

4. Next, dry media is applied over the transfers. Specifically, white, black, pink, and blue chalk and a charcoal pencil are used. The creative combination consists of completing the dark areas over the transfer itself to reproduce or mimic its visual motifs with a realistic drawing. For the most liberal strokes, an eraser is used.

5. Finishing is done with art inks. After fixing the chalk and the charcoal, an overall orange glaze and a few brushstrokes of blue ink are applied with a wide household-type brush. When the ink is dry, a fragment of the *Cántico espiritual* by San Juan de la Cruz, *"ni cogeré las flores, ni temeré las fieras"* (I will neither pick the flowers nor will I fear the wild animals), is written in graphite pencil.

Other versions

In this project the transferred photocopies are used as the image from which the drawing begins. It continues in an autonomous manner without depending too much on those images, or concealing them completely. The gallery shows how the artist has taken the combination of the different media to areas that are more or less Baroque, without renouncing the poetic language created by the tension between images.

NI COGERÉ LAS FLORES NI TEMERÉ LAS FIERA

This Baroque-looking drawing clearly summarizes the great many combinations that are possible in an experimental project. In addition to the transferred photocopies, watercolor graphite pencils, colored pencils, chalks, colored inks, and India ink are used. The result is full of vitality and complexity.

Here, the artist begins with the transfer of another photograph, but the focus is different. Darker and more atmospheric, it evokes the humidity of the forest's underbrush. The light on the leaves of the ferns is done with a chiaroscuro using the art inks and the combination of small pieces of white chalk with long brushstrokes of India ink, applied with a fan-shaped brush.

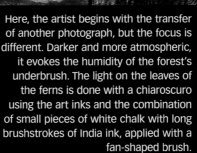

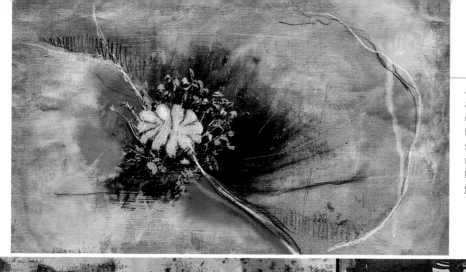

Another very clean approach shows the total absence of shading. The work focuses on the detail of the inside of the flower. White glazes have been created with a few wet brush-strokes over the two white chalk lines, the red areas are done with watercolor pencils. Details are applied with a medium-lead graphite pencil.

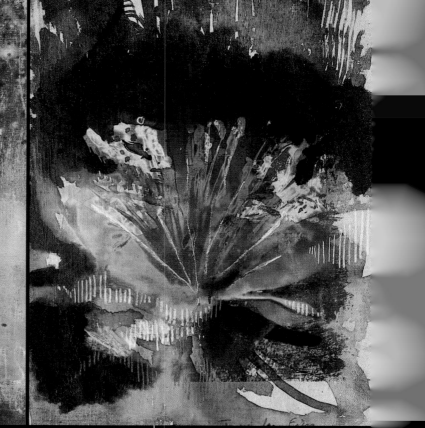

This is the most pop art piece in the gallery. It begins with a photocopy of a different flower, whose petal arrangement adds a "hippie" esthetic. The inclusion of verses adds lyricism and freshness to the piece, as do the play of color inks applied with a paste-like consistency on the background and the small flower drawn with chalk.

The minimal presence of color makes this drawing the most somber of the gallery. It experiments with combinations of India ink and white pencil hatch lines. The most interesting aspect is the drawing done inside the transferred image, partially or completely concealing some of the areas with glazes and hatch lines.

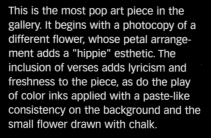

As a contrast, this piece presents the dialogue between the image and the empty spaces. The artist has not drawn directly over the transferred photocopy. Instead it is preserved in its entirety by using white primer to create a box underneath over which a pencil drawing of the reflection of a very delicate flower is drawn. Other delicate elements, such as the stamens drawn with white chalk or the blue and red details, give the piece an elegant poetic flair.

06 Window

New approaches

Other views Through the entire project the artist has created a visual discourse based on an image focused on a small number of flowers—between one and three—and their more or less textured surroundings. To get another perspective, this piece focuses on repeated images by transferring eleven photocopies of the same flower in different sizes. The same series is interpreted three times using different media. First, the contours of the flowers are drawn again with a pencil next to each transfer. Next, the same is done with yellow chalk, focusing on the structure of the stamens instead of the contour. Finally, the theme is synthetically interpreted with chalks, drawing schematic red lines that contain a touch of white inside. The final effect is a multiple image created with thirty similar, but different, flowers—much like an artistic print.

Other models To create a very different point of view in this project, Josep Asunción has transferred different photocopies from an old linotype catalog showing illustrations and plans of various machines onto the support. From this image, which is colder, more technical, and less organic, he has developed atmosphere and structures that go well together with the transfers, providing visual tension and a poetic feeling to the piece. The whole experience is very interesting. It is uncommon to work with illustrations that are so far removed from art, although they resemble old prints or drawings from the Renaissance period that combined art and science.

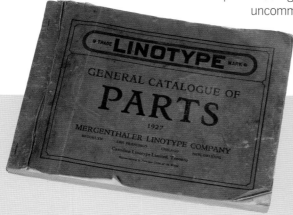

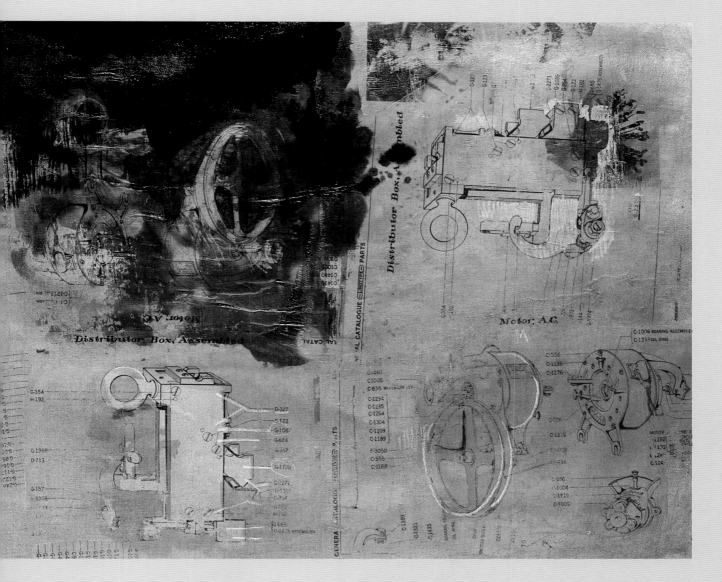

Neasden Control Centre,
Page from his art book *Smithfield Building,* Special Red Edition, 2006.

The street paintings that made their appearance throughout the Western world in the 1960s were created by young people rebelling against the establishment during a time of unrest. Twenty years later they became known as street art or graffiti. The greatest exponent of this genre was Jean-Michel Basquiat (1960–1988), who became the creator of a new visual language. From that moment on there has been a rich underground art movement attracting artists who are completely detached from established art circles—those with very little exposure in museums and traditional art galleries and influenced by comics, manga, digital art, Latin and electronic music, tattoos, and the pixel images of videogames. They make their art known through sources like the Internet (often called net-art), books, record jackets, graphic design for skateboarding and surfing, decals, figures, art for bags and T-shirts, and specific projects for public spaces or fashionable hangouts. These are new artists with a new audience.

Art critics and the media have produced a rich discourse, not without controversy, about this form known as street art, urban art, and even "vandalism" or "art of visual disobedience." Many current artists have become well known in this genre and are internationally renowned. Among them are Barry McGee (United States), Takashi Murakami (Japan), founder of the Superflat movement similar to comic manga and anime, Invader (France), who has placed small mosaic pieces of aliens in all major cities of the world, Groovisions (Japan), the team of graphic designers behind the Chappies, and Neasden Control Centre (United Kingdom), whose work moves freely and creatively between drawing, digital art, collage, and graffiti to convey a personal interpretation of present-day culture—a new era of globalization and technology.

Free expression
with marker graffiti

In the following project, Gemma Guasch works on a series of drawings, applying visual codes from street art and the new currents of urban art: overlapping of images, combination of formal representation and informal graphic interpretation, freedom in the use of color and line, visual dynamism, and a dose of incorrectness and rebelliousness in the message. The selected medium is markers, a fairly new material that provides rich colors and an array of line designs. Marker lines are very graphic and technical, and provide results that fit well with the type of drawing required by fields such as design, illustration, and graffiti, and distance themselves from the traditional view of drawing. The model for the project is a series of photographs that the artist took in two northern European cities: Stockholm and Copenhagen.

"As a child I was a terrible artist; too abstract, too expressionistic, or I drew a ram's head that was incredibly chaotic. I never won any painting contests. I remember that I lost to a boy who drew a perfect Spiderman… My work was 80 percent anger."

Michel Basquiat,
interview with Henry Geldzahler for the magazine *Interview*, 1983.

Creative Techniques: **Drawing**

Step-by-step creation

1. The drawing begins by painting two areas of color with light yellow and cerulean blue markers with wide tips. Then, the silhouette of the two towers of the buildings is drawn in Copenhagen, using very thin markers. The angling of the towers creates a dynamic composition. Also, the areas of color, being so transparent, convey a feeling of freshness.

2. A very wide marker is used to draw a few lines for the buildings. The diagonal angle of the composition is retained by conforming the buildings to that format. The thick marker makes it possible to describe the buildings by their shadows; visually they are perceived as complete forms.

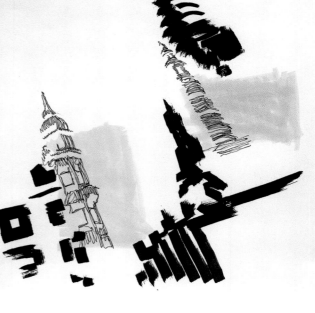

3. The initial lightness and freshness is restored by drawing hatch lines with thick light-pink markers. Before doing this, the areas that we want to color are painted with a solvent marker so they can be blended to maximize their warmth and texture. Next, with a very wide magenta marker, parts of the tower are drawn on the right side of the paper. The object is not to delineate it in its entirety, but to suggest its presence.

4. The different fragments are unified with a large light-green marker. The first yellow strokes of color are juxtaposed, but they can be distinguished thanks to the transparency of their tones. Next, the different parts of the city are drawn with various wide yellow, blue, and opaque white markers.

5. The piece is finished by combining colors. A thick lilac marker paints an opaque area of color on the upper part, leaving the lighting fixtures and their wires exposed. On the lower right side the opposite effect is achieved by drawing the lighting fixture and its wires with thin lines. The final result is dynamic and fragmented, like urban life itself.

07 Gallery

Other versions

Street, or urban art, is common to cities all over the world. It is difficult to stroll through a city and not find walls covered in drawings, signatures, and logos of a counterculture that emerged a long time ago and is not about to stop any time soon. With this idea in mind, Gemma Guasch has worked on this gallery with freedom and the desire to fuse together different graphic languages.

A ledger page with a few partially erased entries is the background for this drawing. This creates a support that contains visual obstacles that a street artist may encounter. The urban image has been drawn with superimposed lines that create an interesting composition by layering.

The chosen support is a yellow glossy paper. A casual and liberal approach to the drawing—and the colors used— give this piece a wild, direct, and spontaneous feeling. The collage consists of a glued fragment of a photocopy painted with blue ink and a part of another drawing of the same theme. This provides new possibilities and touches on graphic arts.

The dark, black wide-marker areas in the center of the drawing tie this composition together. The strokes and the lines are alternated around the center, describing a dynamic and spontaneous spiral. The darker areas of color are lightened with white marker lines drawn over them. The positioning of the elements does not mimic reality, instead the inversion and repetition of the light fixture places the viewer in an imaginary space

This piece returns to the yellow glossy paper, whose color and finish provide a look that resembles advertising. This time only the central part of the image is covered with black marker. Behind that the outline of several buildings is drawn with a purple marker, which creates a big contrast because it is the complementary color of yellow. The white marker lightens up the forms of the black mass. The rest of the urban space has been drawn with a light, soft line.

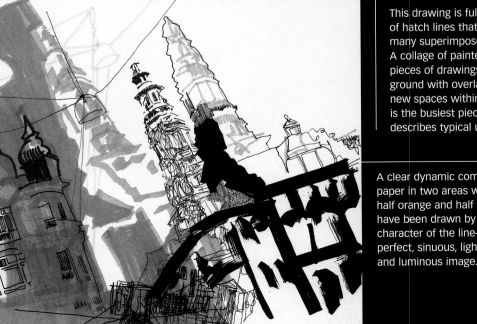

This drawing is full of images with an area of hatch lines that are combined with many superimposed colors and lines. A collage of painted photocopies and pieces of drawings make up the background with overlapping lines that create new spaces within the paper itself. This is the busiest piece in the gallery, and describes typical urban chaos.

A clear dynamic composition divides this paper in two areas with a central diagonal: half orange and half white. The buildings have been drawn by richly varying the character of the line—thick, direct, wild, perfect, sinuous, light—creating an elegant and luminous image.

07 Window

New
approaches

Other views The interaction between languages—comic, advertising, graphic design—is a good basis for planning an urban artwork. Gemma Guasch intended to integrate different fields in this piece. With that in mind, she made photocopies of photographs of cities. The interest of this work resides in the interaction between the image reproduced by a machine and the human touch of marker lines and areas of color. The results are spontaneous and light, without pretensions.

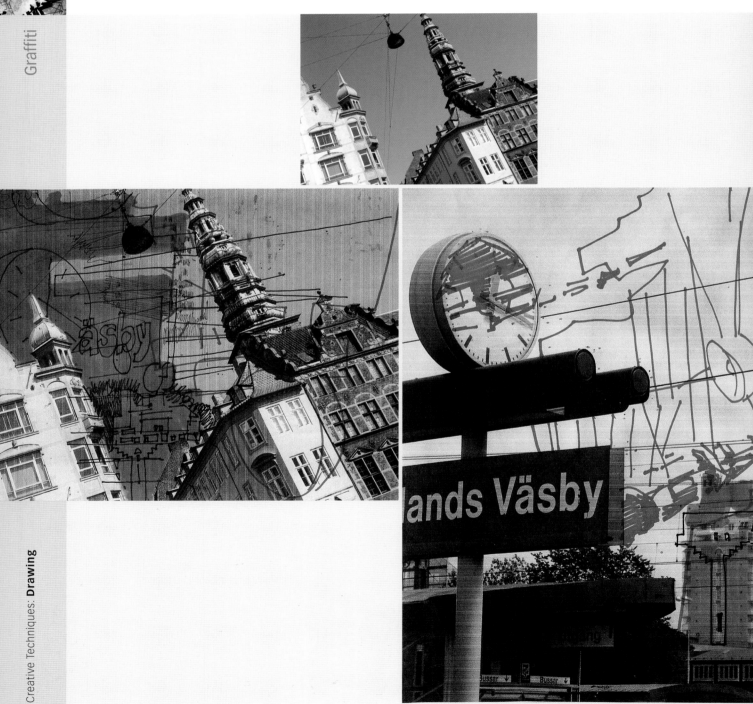

Other models The whole project is based on the images of a city—streets, lights, traffic lights, and buildings. In this instance, Gemma Guasch has chosen a very different image that emanates a counter-cultural atmosphere, but is warmer and more human: a musician playing the drums. Music has always accompanied all the merging movements that have vied to be heard. The inclusion of a person brings this closer to the feeling of a comic. The repetition of the musician in the drawing emphasizes the mystery and enigma. The collage is reminiscent of advertising pamphlets placed one over the other. The wild and spontaneous character of some of the lines and strokes gives this piece a direct and casual feeling.

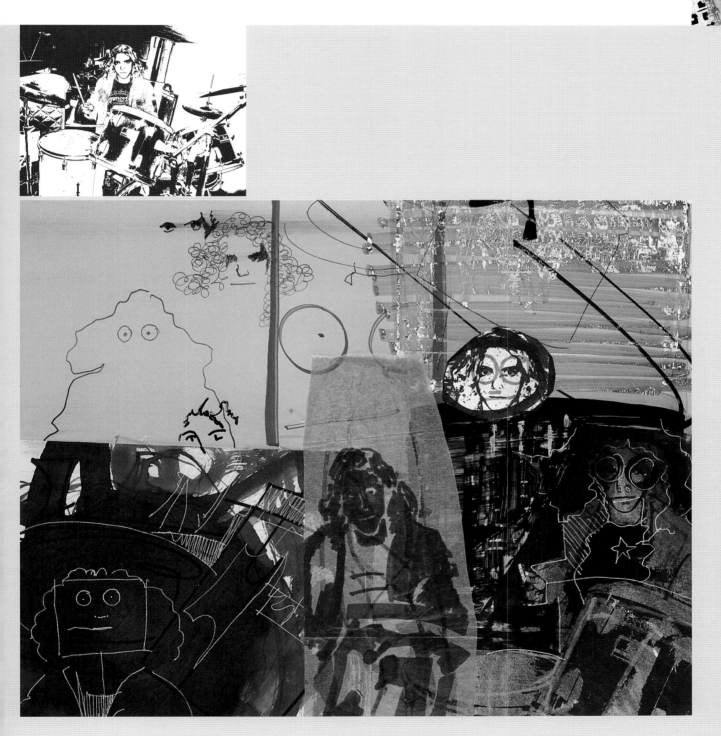

08 Washes

Creative approach

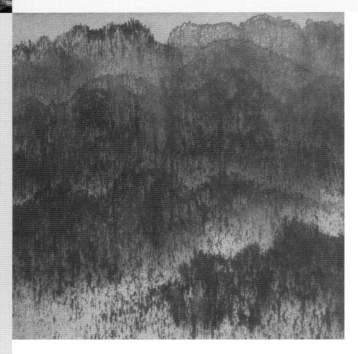

Dai-Bih-In,
Untitled, c. 1982.
Private collection.

In the history of Western art, the human figure has dominated as a genre. In Chinese painting, however, landscapes are revered because they explain all the beauty of the world. This is especially true beginning in the ninth and tenth centuries. In that long and wise tradition of landscapes, Chinese painting has fully explored the creative possibilities of washes, mainly because almost the entire pictorial body of work in China has been created with ink. According to the Chinese cultural tradition, a landscape is not a representation, but a true creation as real as life itself. A Chinese landscape is born from the vital experience of the artist with nature. "Now the mountains and rivers ask me to speak of them; they are born in me and me in them," said the great painter Shitao (1642–1707) in his treatise on landscape painting. Men's dreams and characteristics are expressed through the landscape. The work of Dai-Bih-In (born in 1946) encompasses a perfect balance between energy and poetry. His pieces reflect not only the world in which he lives (the northern part of Catalonia, Spain), but also the philosophical roots of his native China. Tàpies refers to him as the "artist with a dialoguing and traveler's spirit." His washes convey a feeling of pleasure, of enjoyment, and a positive sense of beauty that is expressed with lines free from formal limitations. In the work of Dai-Bih-In we can see dynamic fresh strokes—loose, always quick, but firm. It does not matter if it is India ink or watercolor on paper, silk, or other material, or large or small formats. Often the brush does not touch the paper and spreads the ink or the water, taking full advantage of the possibilities of the medium. The glazes, spattering, or washes form misty or reflecting areas in the purest Taoist tradition, which considers the water in the landscape yin and the mountains yang.

Experimenting with ink washes to create expressive landscapes

Washes offer many creative possibilities. Several different factors are involved in a wash: the amount of water in the India ink, how much is in the applicator, the applicator, the effects of the line, the type of paper used, and whether it is damp or very wet. With all these variants, Josep Asunción has treated this landscape in a creative way to produce an interesting project executed with India ink on glossy and heavy watercolor paper.

To join the ink and the brush is like resolving the difference between yin and yang, and to begin revealing chaos... like rooting the spirit firmly amid an ocean of ink; having life confirm and spring from the tip of the brush! Like achieving metamorphosis on the ink surface; having light bloom from within chaos!"

Shitao. *Yinyun,* Chapter VII, 1700.

Step-by-step creation

1. The first color on the paper is a large wash that begins to define the sky of the landscape. First, the area to be covered is washed with clean water, and then the silhouette of the mountains in the distance is drawn with thick ink, letting it dilute partially and naturally with the water from the wash.

2. The foundation of the water's features, which consist of wavy lines applied with a flat sponge brush and diluted ink is painted. A small amount of thick ink is added to the closest lines with a brush to create a light chiaroscuro. The ink is allowed to dry before continuing.

3. An overall gradation is applied on the surface of the water. The surface is first wetted with water darkened with ink. Ink is then applied horizontally with a flat wide brush only on the upper part to create a soft gradation. The initial wet area should not contain too much water, only enough for the ink to dilute softly.

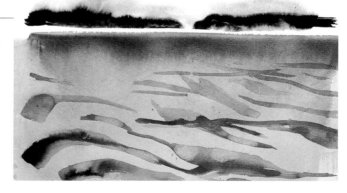

4. When the wash of the previous gradation is still a little wet, water is spattered to create a few white spots with a textured effect. The masses of vegetation are defined on both sides of the landscape. First, color is applied with a thick, ox-hair round brush and diluted ink, wiped vertically with a very flat brush to obtain a spongy blend. Once dry, work continues on the reeds with parallel hatch lines applied with a fan-shaped brush.

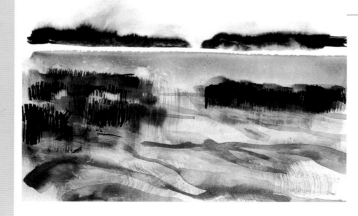

5. Creation of the atmosphere continues with a glaze in the lower area of the landscape. To create the glaze make a few reserves with a wax candle and then a wash of diluted ink, which will allow some of the previous ink lines to show through while leaving the most luminous lines of the reserve exposed.

6. To finish, emphasize the dense and romantic atmosphere of the landscape. A new glaze of light ink is applied; this time it covers the distant area of the water up to the horizon in a visual fog. A series of more gestural and defined lines is made on the reeds and the water's waves with a fan-shaped brush.

08 Gallery

Other versions

The magic of washes resides in the way the diluted ink reacts with water. The response is not always foreseeable and can produce surprising visual textures that are very suggestive. This gallery presents some very different washes that are the result of experimenting with water and other substances.

This landscape is the result of a more experimental and risky process, thanks to a minimalist approach that gives presence to empty spaces within the work through the techniques involved. The expressivity of splattering is worked with quick lines made with a wide brush heavily charged with light ink. Textures are applied with quick strokes of ink mixed with essence of turpentine, a combination that is impossible to dissolve because the essence of turpentine is oily and ink is water based.

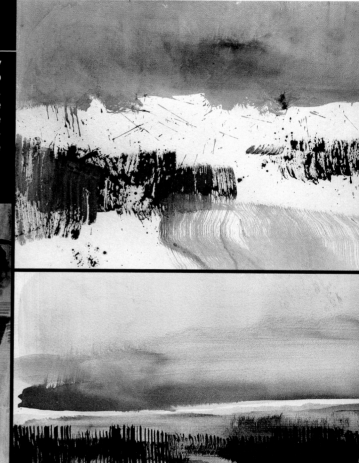

This wash combines various lines and different ink densities. Over a background of ink gradated and blended with a wet, wide brush, a large area of thick ink is mixed with a light charge of coffee grounds that gives it texture and density. The other lines are done with a medium-wide bristle brush and dragging and syncopated movements.

Over a very airy background, created by brushing with a wide brush and modeling with a flat sponge brush, hatch lines have been drawn with a fan-shaped brush and thick ink. The effect is a visual contrast between the soft and ethereal qualities of the water and sky and the harshness of the reeds.

Another very clean result is this work in which there is a certain lack of atmosphere. It focuses on the gestural, graphic quality of abstract ink lines made with a wide brush, and on the spattering effect. Drawing the horizon with a ruler and pencil was a wise decision because it gives the line great precision, which is in contrast with the expressionistic modeling of the rest of the lines.

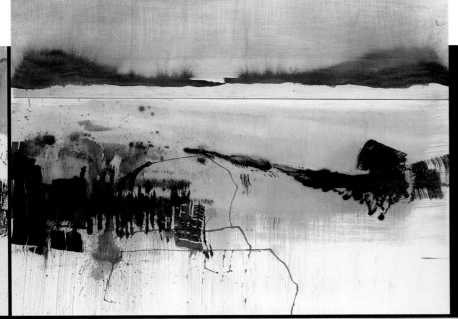

Here we can see several atmospheric and textured effects: the airy blending of the sky, created by brushing with a wide brush over an area of wet diluted ink; the areas of light created with alcohol splattered over the wet ink, which leaves a dark border; and the spattering of thick ink over the wash after it dries.

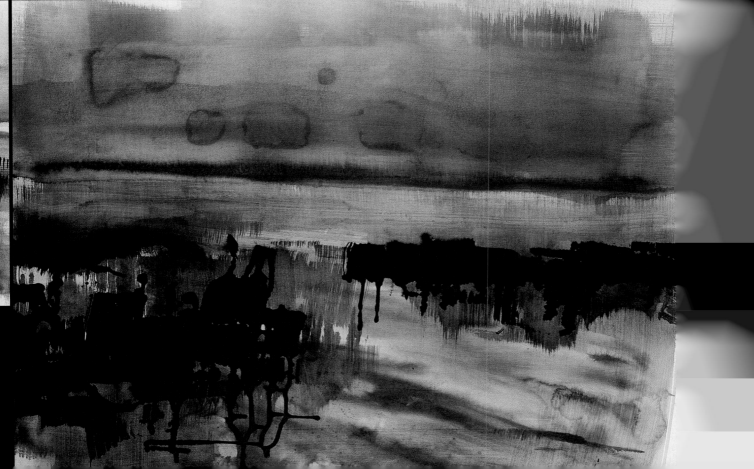

08 Window

New
approaches

Other views All the washes in the project are based on the way the ink reacts on wet, white paper. In his desire to offer different views, the artist has made two different washes. One of them begins with black ink on white paper, but finishes with white ink over black. The white ink is a white pigment with a binder that is easily diluted with the black ink and water, although the results are more pictorial. In the other wash, he took the risk of reducing the landscape to simple flat black, gray, and white surfaces, achieving a minimalist abstraction of great poetic effect. The black ink of this work, which contains a charge of coffee grounds, has been finished with a charcoal fixative to preserve its grainy texture.

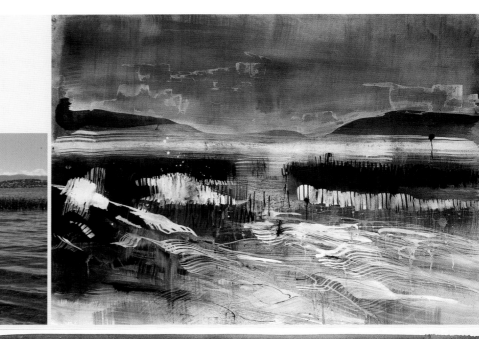

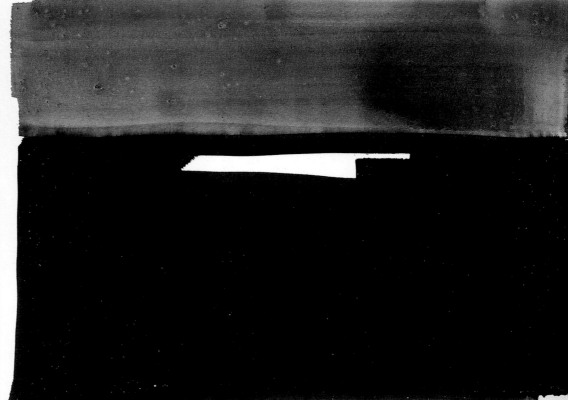

Other models The two great features of Chinese landscapes are the water and the mountains. In many ink landscapes, Chinese artists include both elements because they symbolize the yin (receptive energy) and the yang (intervention energy), respectively. To use a different model, Josep Asunción works with a very special mountainous landscape: the valley. In Chinese landscape painting the valley acts as an intermediate space between yin and yang, the place where the void, the mystery, and the first energy, which the Taoist tradition calls *dao* resides. The ideal artistic medium for producing this void is fog, and the artist has created a rich combination of very airy, gestural, and spontaneous lines to represent it.

09 Abstractions
Creative approach

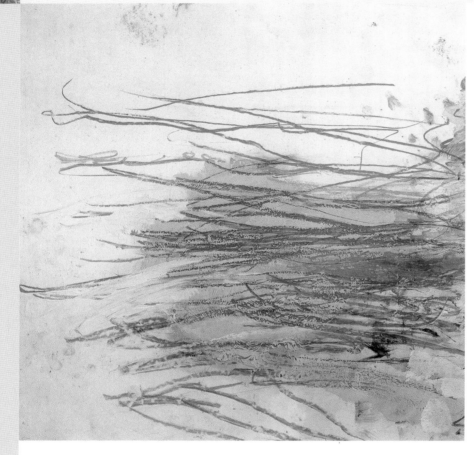

Cy Twombly,
Gaeta Set (for the love of fire and water)
page 6, 1981.
Private collection.

Although Cy Twombly (born in 1928) is a member of the American Abstract Expressionist movement, he never renounced his ties with Europe, and this is reflected in all his work. Like his colleagues, he shows a Surrealist influence using automatic writing and psychic improvisation. In 1951, together with Robert Rauschenberg, he made his first trip to Europe where he visited France and Spain and made a short stop in Morocco. Working in empty, white spaces facing the ocean made a big impression on him. Twombly remained in Italy until 1952. In 1957 he moved to Rome, where he resides to this day. From that moment on the Mediterranean culture has played an important role in his work, emphasizing its poetry and its relationship with the myths and traditions of antiquity. His style, based on quick graphic depictions and a marked Expressionistic stroke, is present on his canvas like a unique metascripture. At the end of the 1950s he began organizing his copious body of work on paper. The series *Gaeta set*, from 1981, amplifies drawing and incorporates gouache, wax, and paint. In the drawing *Gaeta set (for the love of fire and water)*, the paper remains free and white and writings are expressed through lines and areas of color, which intend not to represent, but to express, the water that arrives, puts out, and extinguishes the fire. These lyrical and poetic calligraphic strokes draw inspiration from mythology and classical history, but read as total abstractions rather than traditional iconography.

Abstraction as a creative medium for crayon drawings

Images viewed through a microscope reveal innumerable creative possibilities. In this drawing, the image of a few cells seen through the microscope has given Gemma Guasch the inspiration to create abstract drawings. Since crayons are an oil medium they can be worked directly and blended with an eraser, a finger, or diluted with turpentine. Their use makes it possible to create a drawing of rich and varied lines.

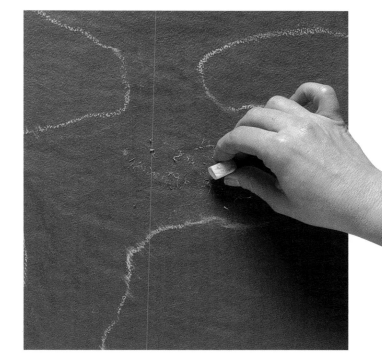

"Each line holds its own present awareness, of its inner story. It does not explain anything, it is the result of an individual incarnation."

Cy Twombly, 1957.

Creative Techniques: **Drawing**

Step-by-step creation

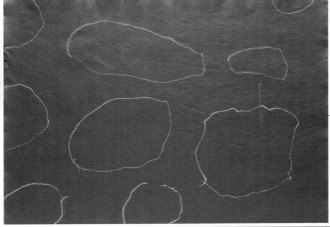

1. Various circles are drawn with a white crayon on a sheet of burgundy handmade paper. The circles do not have to be perfectly round or need to be centered on the paper to achieve a spontaneous and dynamic composition.

2. Next, following the outline of the shapes created, other circles are drawn with an orange-yellow crayon. Once complete, the lines are wiped with a rag. Pressing hard gives them a blurry look.

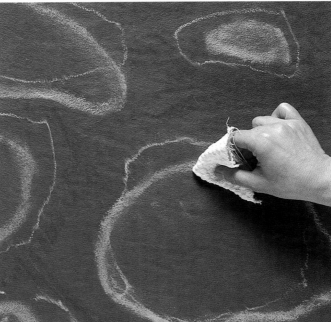

3. The white crayon is used to draw more circles. These are partially erased to create a zigzag effect. Next, a violet-colored crayon is used to draw more undefined lines. These are later erased until they blend with the color of the background, leaving them almost blurry.

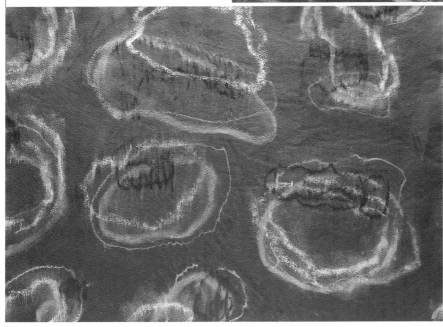

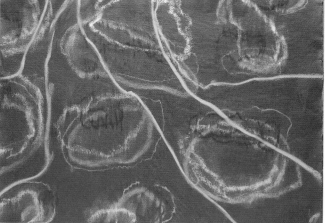

4. To enhance the dynamic composition with layers, vertical and rounded lines are drawn with a white crayon, dividing the image into several sections. Running a finger over the central lines creates a strong and silky effect. The eraser is used on some of the lines to achieve a soft and blurry look.

5. To finish, long, vigorous lines are drawn. The circular shapes have become brighter from the effect of the eraser. The vertical lines are wiped off again with a finger or an eraser, depending on the effect desired. The result creates an inviting and dynamic feeling.

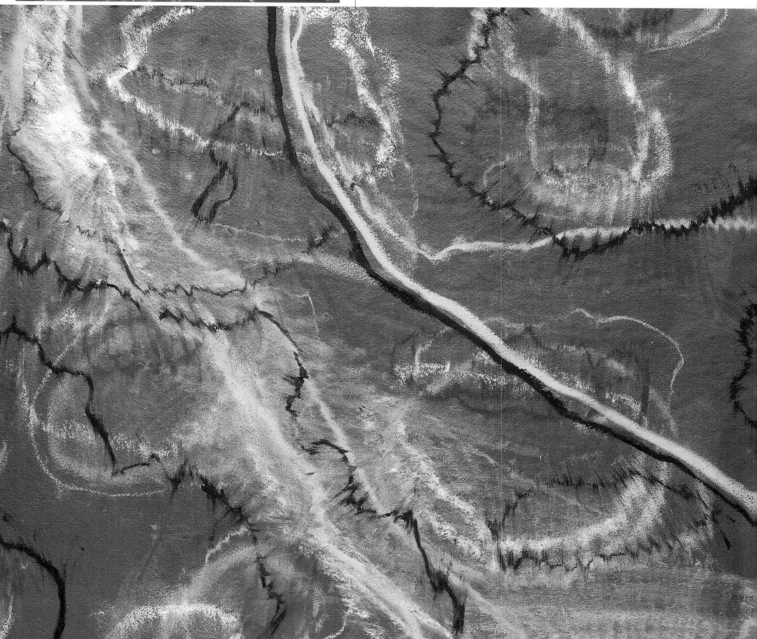

09 Gallery

Other approaches

This time, the author has created different worlds inspired by the abstraction of the images obtained through the microscope. The flow and versatility of the lines and textures that can be achieved with crayons make for a rich and varied gallery.

This drawing depicts a single circular shape achieved with a direct and contrasted line. First, the paper is colored with a white crayon held lengthwise, applying very little pressure. Next, purple is drawn over the white, which enhances the color and provides contrast. The other bits of crayon lines are made by applying direct pressure and retouching.

The creamy density of crayons can be perceived in this energetic and dynamic abstraction. The forms bunch up next to and inside of each other as if something were pushing them. The layered effect of the crayon lines is created by wiping them down with a rag or with spontaneous strokes.

Here the drawing is more subtle and minimalist, with a more atmospheric and delicate treatment. The crayon lines have been juxtaposed, exposing their layering through the different colors. This creates a pleasant dialogue between the dark masses of color and the light ones.

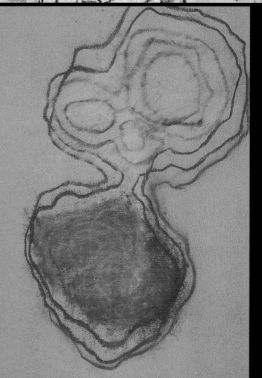

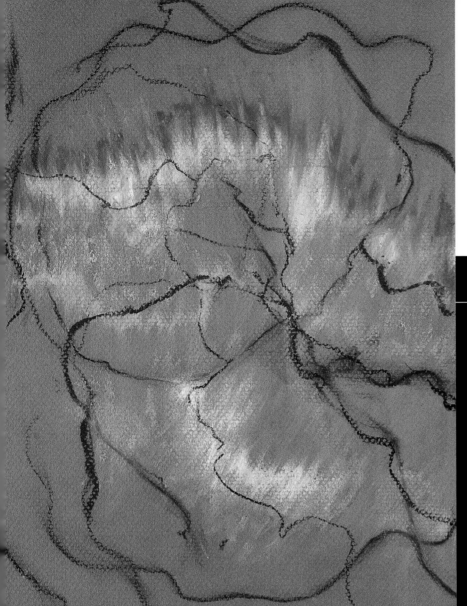

A more linear use of crayons without heavy masses of color produces a drawing that emphasizes the variety of lines. An eraser, used more vigorously over the colored crayons and less directly on the black crayons, produces an atmospheric and dynamic effect.

Two large masses of color—drawn by applying very little pressure on crayons placed lengthwise on the paper—constitute the basis for the drawing. Over them, a single, wide outline is drawn on one side with the wide part of a stick of white crayon, contrasting with the many thin purple lines.

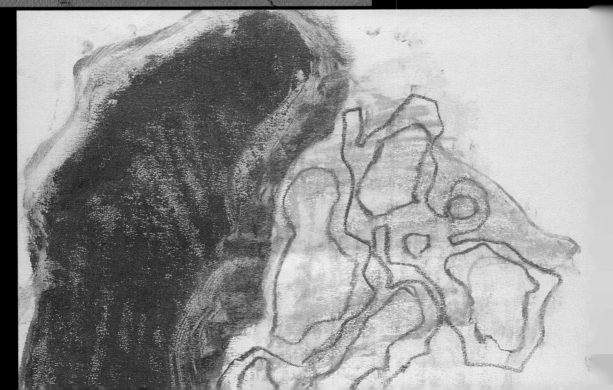

Other views In all the previous drawings the crayons have been used as a dry medium. To create different examples, Gemma Guasch employs the monotype technique as an experiment. She has used a generous amount of solvent—essence of turpentine—and drawn several circles with the sgraffito technique. Crayons are first worked on the paper; the paper is then wetted with the essence of turpentine, and finally an identical piece of paper is placed on top, over which she has drawn circles with a pencil. When the papers are separated the result is a drawing of a creamy texture, created by the crayon diluted with the turpentine, which contrasts neatly with the sgraffito.

Other models The main motifs of the abstractions so far have been images seen through the microscope. Here, Gemma Guasch has chosen a very different model: fractals. The shapes of these are already abstract, which makes it easier to plan a natural abstract drawing. The crayons are worked in layers to enhance their creamy texture and to create an atmospheric effect. Rounded white crayon lines add light to the final drawing.

10 Space and atmosphere

Creative approaches

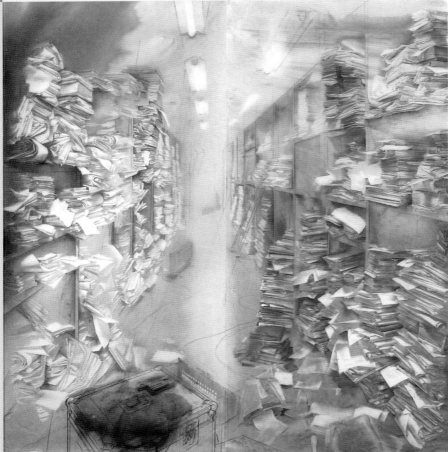

Julio Vaquero,
Espacio de formas obsesivas.

Realism and creativity are not at odds. Most realist artists resort to creative approaches for expressing realities that transcend the mere representation. Julio Vaquero (born in 1958) is a solid representative of the new Spanish realism. This realist painter focuses on the study of the natural, using drawing in an experimental way. He develops new approaches based on compositions of objects that are carefully arranged in his studio under very deliberate lighting conditions to evoke a feeling of mystery and transcendence. In his drawings, done with oil pencils and graphite washes, usually on large-format tracing paper, we find a perfect tension between correctness and spontaneity, realism and abstraction, and a polished and muddied look. Vaquero seemlessly combines classical mental and analytical drawing with the intuitive and sensorial manner that is attributed more to non-formalist currents. In his work *Espacio de formas obsesivas*, a large 81½ × 80¾ inch (207 × 205 cm) drawing, space is, as in other similar pieces, represented, rather than re-created. The drawing resembles an installation more than a still life or rendering of an interior space. In these drawings there are ambiguous elements that could be considered between two- and three-dimensional, between a graphic composition and a volume; this is due in large part to the elements in the work that are perfectly finished next to others that are only vaguely hinted at.

Using dry techniques to create visual and atmospheric textures

To experiment widely with the expressive possibilities of dry techniques, Josep Asunción presents a project based on the atmospheric effect created when the sunlight fills up a space that is worn out and full of textures. In this work he used graphite powder, charcoal powder, graphite pencils and sticks, white chalks, and pastels, in addition to rags, erasers, brushes, wide household brushes for erasing, and applications of diluted graphite. The support is heavy vellum paper, on which it is easy to incorporate or remove pigment without damaging the fibers. It also withstands washes well. The model is a very special space: the depot of an abandoned train station. Its walls are already rich in textures, and the sunlight that comes through the openings of its structure in ruins creates the atmosphere that the artist sought. Overlapping the points of view is an Eastern technique that creates a vivid, rather than represented, space.

"Drawing is a basic approach in my overall concept... I know that I have made a contribution mainly in my drawing... instead of using profiles, instead of creating forms and separating spaces, my drawings declare the space. Instead of working with parts of the space, I work the entire space."

Barnett Newman,
interview with Dorothy Gees Seckler.

Step-by-step creation

1. The first step consists of preparing the support to make it more appealing and to break up the uniformity of the paper. This is done by applying graphite powder mixed with water. We use this opportunity to apply loose strokes, spattering, and areas of different densities, mimicking the worn look of the depot's walls. Strokes of diluted sanguine are applied in some areas, expanding the chromatic palette.

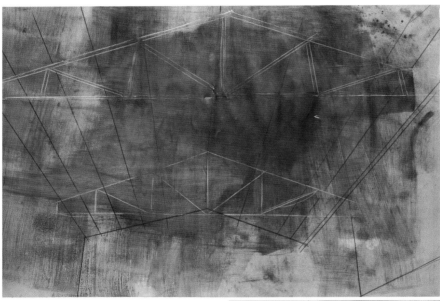

2. Once the background is properly prepared the more concrete drawing, which will reproduce the space seen from different angles, can proceed. The first is an image of the roof of the depot from a central point of view, looking up. This is done by drawing the structural lines of the ceiling with graphite and white pencils, using a ruler. Care is taken to draw the perspective properly and maintain accurate proportions.

3. To create an image that is more complex and less explicative, other views of the space are inserted into that drawing. These are selected from the opposite side of the depot, where there is a round window and the ceiling is somewhat damaged. The lights that are created in the roof of the first image are drawn first with light gray, and the roof's lower angle is highlighted with black chalk. This way, the image cannot be easily recognized, creating a level of mystery.

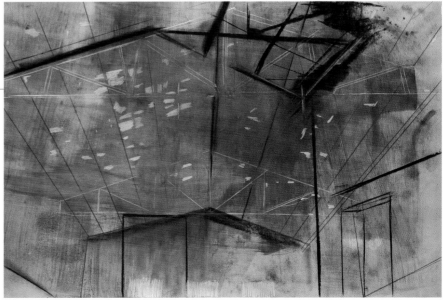

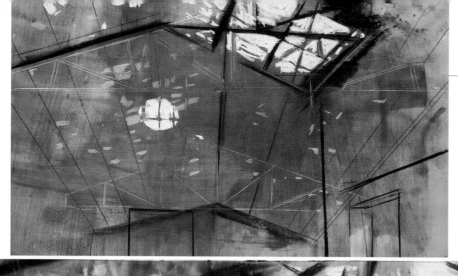

4. Work continues on the second view of the depot, which incorporates the light from the broken roof and the round window. Pastels are used to create a more luminous white and white chalk creates the sunlight that comes through the lower openings. The pastels and the chalk are fixed to prevent them from smearing accidentally during the process.

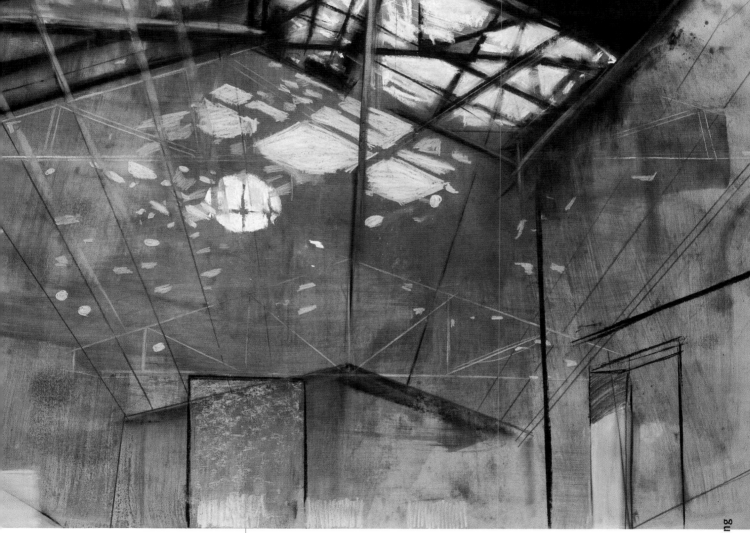

5. To finish the drawing, projections of the light on the walls are added with white chalk and areas such as the shadow from the frame of the side door and the colors of the lower opening in the middle are completed. The result is a beautiful harmony between visual texture, linear structure, and light; all of this creates that special atmosphere found in decadent spaces.

Creative Techniques: **Drawing**

10 Gallery

Other approaches

The basis for this project is the gradual incorporation of spatial structures and combined textures. The effect can be very different, depending on how daring the artist is in the use of combinations and composition. In all the images there is a certain visual mystery; a deliberate awkwardness that forces the spectator to contemplate the space.

The only vertical image of this gallery is based on a composition whose strength comes from the diagonal beams in the ceiling and the light that crosses them. A second basic structure executed with white pencils breaks the logic of the composition. The texture created with charcoal powder and graphite mixed with water for the initial colors is very appealing.

For this piece work begins with graphite powder applied with a cotton ball and splashes of water on a uniform base. Next, the graphite dampened with the drops of water is removed to create light areas on the paper. The rest of the work consists of describing in detail

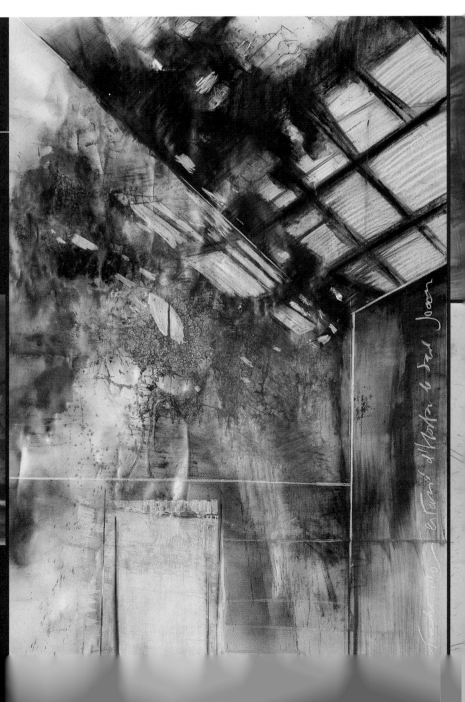

This complex composition is based on the overlapping of orthogonal and diagonal hatch lines, in addition to the poetic play between different spatial planes. There is a general plane, a middle plane, and a closer plane centered in the circular window. This approach creates a feeling of depth.

This is the most complex work of the gallery. We have started with a base that already contained the geometric structure created with reserves made with masking tape, placed before the overall application of color. Next, we have made full use of the lights by reproducing them in different sizes and from various points of view. Sanguine adds tension, as well as a dialogue between silhouettes and flat areas of color, and the hatch lines and blends made with chalk and pencils.

This is the brightest drawing of the gallery and starts with a background that is not as elaborate as the one before. A large area of color created with a mixture of graphite powder and charcoal powder diluted in water is applied vigorously with a wide household brush, using circular motions to produce many areas of spattered color. A very clean pencil drawing is done over the base.

Another view This time, the artist uses his imagination to develop the same spatial approach with slight variations, interpreting the light and the atmosphere with color. To do this, colored chalks are used over a background worked with areas of diluted graphite powder, over which pastels have been blended. The bright colors of the chalks transform the decadent theme into a fantastic one, providing a more idyllic view of the space, as if the sunlight came in through stained glass windows to fill the atmosphere with optimism and vitality.

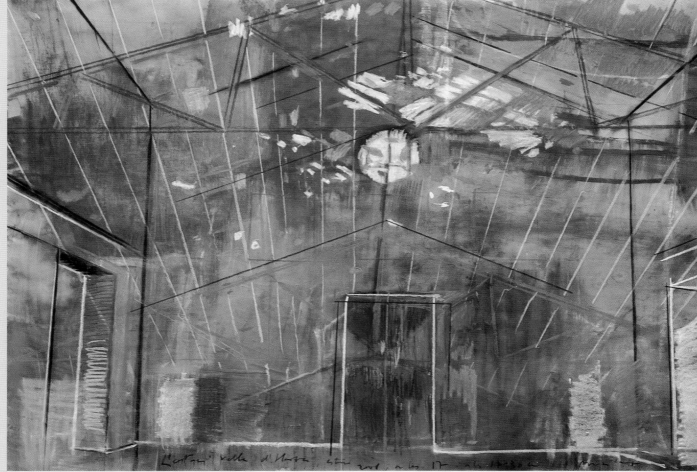

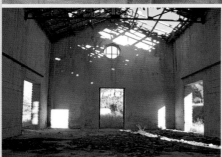

Another model Even though the theme running through the entire project has so far been an interior space, the artist now applies the same creative and technical approaches to an exterior environment: a landscape. He has chosen to use a forest, because its thick brush is an ideal subject with which to express the feeling of atmosphere, thanks to a richness of textures, numerous visual stimuli, humidity, and filtered light. Starting with a textured background, he draws horizontal lines. Over this base he applies many different types of lines—vibrant, hatch, blended—and details. Different points of view do not overlap because the different stimuli offer enough variation to incorporate lines and areas of color in a rich and complex symphony.

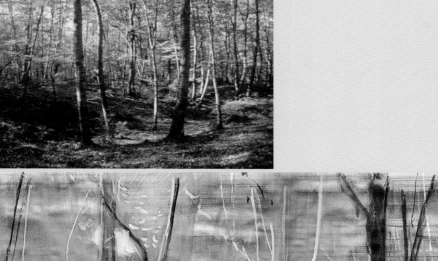

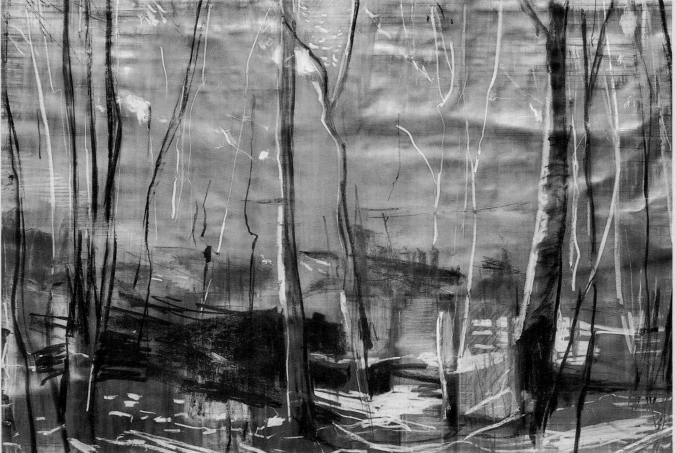

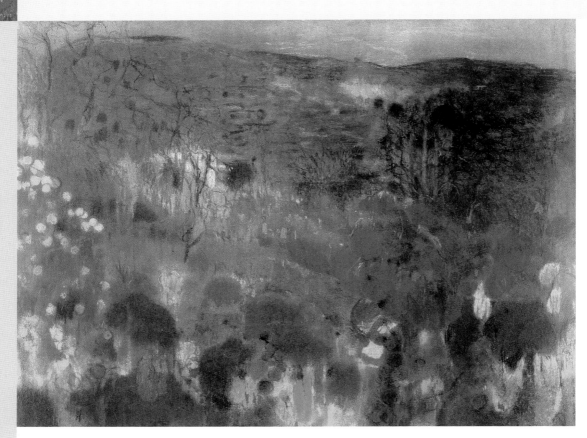

Joaquim Mir,
L'Aleixar, c.1917.
Private collection.

Pastels are an ideal medium for the creation of color drawings. Impressionist, Symbolist, and Nabi painters like Joaquim Mir (1873–1940), considered one of the best Catalan landscape painters, exploited this medium to the fullest. True to the mood of his period, Mir worked in contact with nature, representing the images that he received intuitively from its contemplation. He was part of the second Catalan Modernist generation. Mir's work was constantly evolving; he was a solitary, primitive painter with a touch of wild. Together with Isidre Nonell, he formed part of the *colla del safrà* (the saffron group), a name derived from the yellow and orange colors that were predominant in their work. He lived the bohemian life, meeting with avant garde artists at the Barcelona modernist café Els Quatre Gats. During the period between 1907 and 1917, to which the pastel drawing *L'Aleixar* is attributed, Mir resided in Tarragona, Spain, where he conducted his work free of social pressures and recognition, pursuing an intuitive, expressive, and personal path, and a renewed visual language that allowed color and line to emerge freely. His work acquired an expressionistic and abstract tendency, exaggerating the light and color vibrations, defining the landscape through movement rather than through representation of reality. He minimized the details, took the focus away from drawing, and intensified color, letting the predominant color be the focus. He eliminated the atmosphere and touched a little bit on abstraction. His personality did not allow him to completely abandon reality or the conservative atmosphere of the Catalan Noucentisme that was gaining strength, but it did make him return to a less free and daring style of painting, and to more classical tendencies.

Expressing the chromatic splendor of the landscape with pastels

Pastels are a medium that ties together drawing and painting. The shape of the stick gives the stroke a linear character with which to explore the calligraphic qualities of the lines and the more controlled effects, while the loose texture and the bright qualities of color make it possible to create surface and volume effects. In the eighteenth century pastels became very popular in France, where they were used to paint portraits. Painters like Quentin de la Tour, Chardin, and Rosalba Carrera used and valued them as a fresh and spontaneous medium. Gemma Guasch also chose pastels for this creative project; her goal was to capture the freedom of the chromatic notes of a spring landscape.

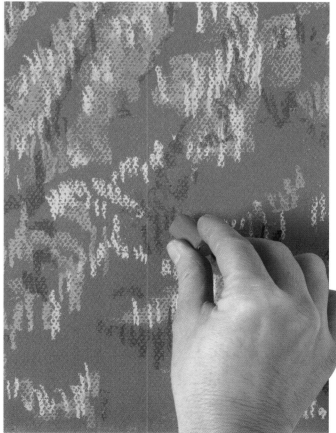

"Color helps to express light, not the physical phenomenon, but the only light that really exists, that in the artist's brain...But drawing and color are only a suggestion. They should provoke ownership through illusion."

Henri Matisse, *Écrits et propos sur l'art.*

Creative Techniques: **Drawing**

Step-by-step creation

1. The one point perspective of the landscape is sketched on red Canson paper using dark green pastels. The combination of green over red strongly emphasizes the color contrast. The pastel stick draws soft and sinuous lines, creating convincing furrows on the land.

3. Over the previous texture small lines are drawn with pastels to describe the grass. White and yellow-green colors provide the necessary touches of light and increase the color expression.

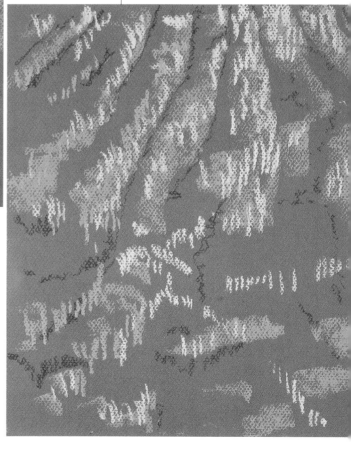

2. Drawing with a light-green stick, held lengthwise on the paper, paints a surface that represents the large grassy fields. The different color notes intensify the energy and vitality of the drawing. The freshness and spontaneity of pastels can be seen through the variety of lines that can be achieved with this medium.

4. Dark tones are added to the drawing. A dark green pastel intensifies the colors of the drawing that was first laid out. The contrast of the different greens suggests the volume of the grass.

5. To finish, red tones are used to suggest poppies. The inclusion of bright and brilliant red pastels over Canson paper (also red, but matte) enhances the luminous contrast. The drawing maintains the spontaneity and freshness that are typical of the medium.

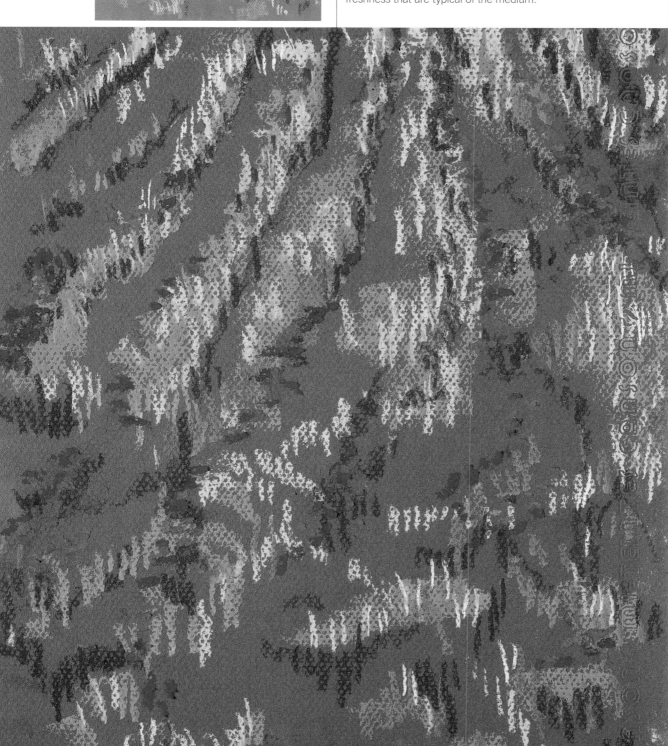

11 Gallery

Other approaches

Varying the color backgrounds and the colors of the pastel sticks achieves a wide range of results, some more atmospheric and others more direct. In all the drawings the landscape takes center stage because of its color and joviality. Enjoy the chromatic impressions provided by this rich and varied gallery.

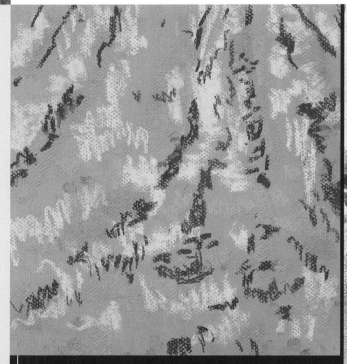

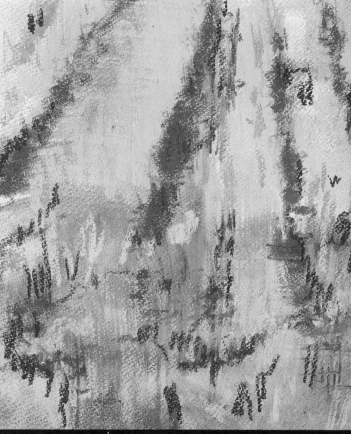

A bright orange Canson paper is used as a background. Over it different tones of green are applied with pastel sticks, barely blending them at all. The reds contrast with the greens and intensify the orange of the background. The pastel hardly covers the paper, providing a drawing that is light and direct.

The ability that pastels have to create atmospheric effects is evident in this drawing. The paper is completely covered with pastels; other colors are overlapped to create dense surfaces and textures. The drawing recalls the soft airy effects of Mir's pastels.

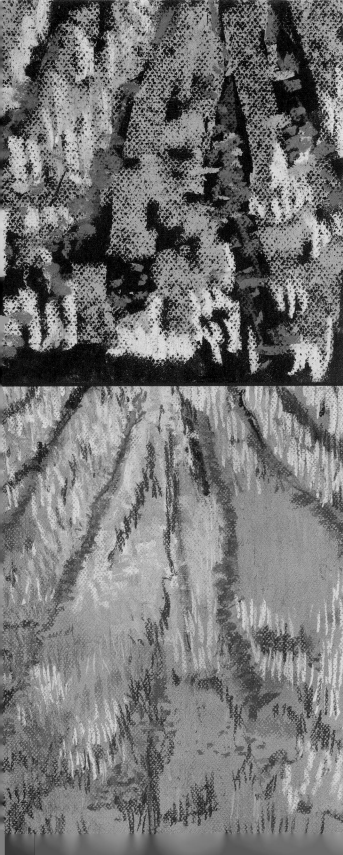

This landscape was executed on black Canson paper. The black of the background intensifies the colors applied over it. The pastel sticks have been used to create very pictorial masses of color; the fact that they have not been mixed together allows us to enjoy the chromatic purity of the color.

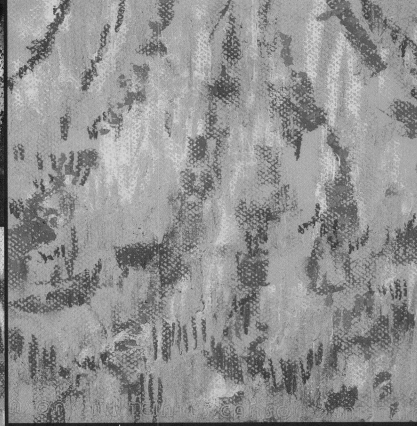

In this drawing the background is again orange, but the resulting effect is more finished. The green colors create the surfaces while the vertical lines generate the volumes through tonal contrast.

The color of the support is a dull orange, which allows the artist to work with combinations of pastels. The modeling of the lines varies freely in form and direction. The powder left by the pastels is finger blended to create atmospheric effects and then drawn over again. The final result is airy and delicate.

11 Window

New
approaches

Another view To add a different point of view to the project, Gemma Guasch uses the same technique with a creamier and denser approach. Horizontal strokes are applied with pastels, creating a static and heavy effect. The pastels have been mixed together to a creamy consistency, so much so that she was forced to apply a fixative to the drawing to continue working. Once it was dry, she continued drawing over it until a dense effect was achieved. The colors have lost their luster and freshness, turning grayish and dull and giving the landscape a somber look that conveys a feeling of eerie calmness.

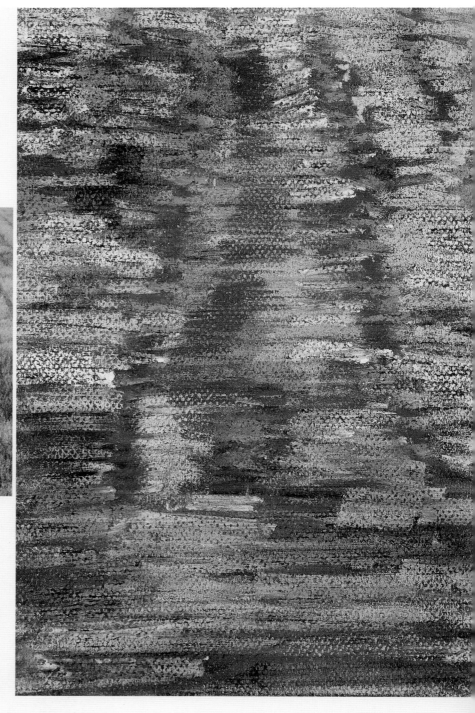

Another model The model chosen as an alternative is a still life with flowers, another approach to nature. Pastels are a medium that is often used to paint still lifes. Here, the artist was able to pay more attention to the form and color of each flower, since the subject is in the foreground and there are no distant views of it. The white tones of the still life and the red color of the poppies are enhanced against the gray background of the Canson paper. With a quick and vigorous stroke the artist has drawn a landscape of outstanding spontaneity and freshness.

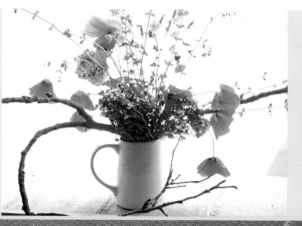

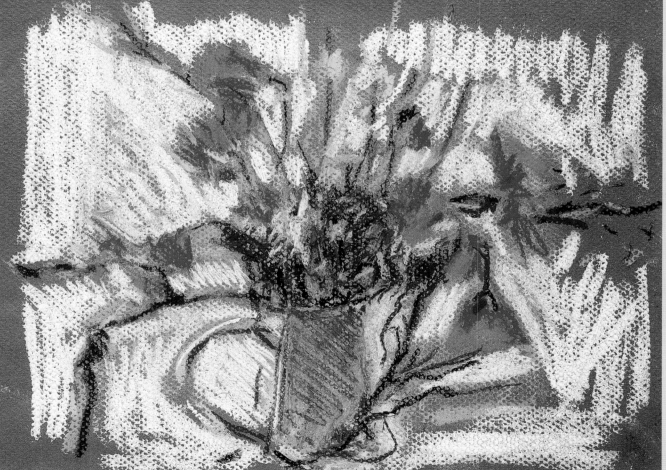

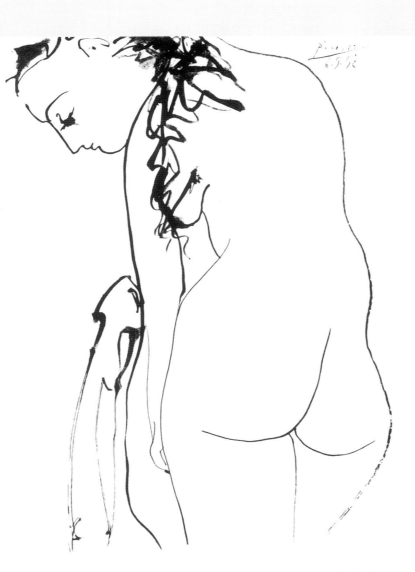

Pablo Ruiz Picasso,
Desnudo de espaldas, 1958.

While large strokes of color in drawing are associated with the senses and intuition, and are the most common approach for creating textures, and atmospheric and modeled effects, the line is associated with a mental function due to its descriptive and concrete character. Lines do not allow mistakes; they clearly show when something is correct or incorrect. The great masters have all been experts at drawing and have shown superb skill with the line. An example of this is Pablo Ruiz Picasso (1881–1973), perhaps the most emblematic artist of the twentieth century. Picasso combined painting and drawing during his entire career, using the latter as a creative language in its own right and also as a tool to sketch paintings. Picasso, like other geniuses in history, is a paradigm of innate talent. Referring to children's art he said, *"When I was their age I could paint like Raphael, but it has taken me a lifetime to learn to paint like them."* With just a few lines he was able to create the most beautiful and expressive drawings, exemplified by *Desnudo de espaldas,* which he drew later in his career. This piece is part of a larger group of ink drawings in which he expresses his love for the beautiful bodies of young women and his sincere frustration with the difference in age that separated him from these objects of desire.

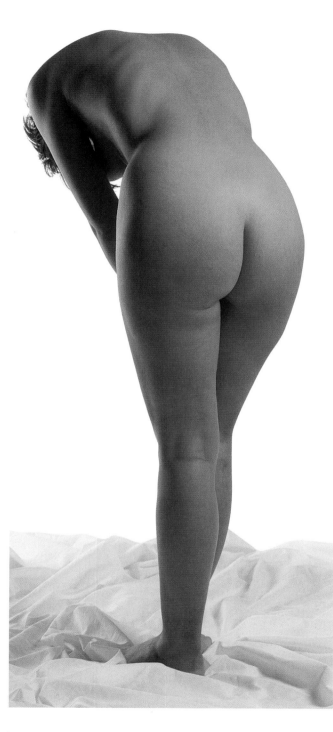

Discovering the many possibilities of the ink line

As with both Eastern and Western calligraphy, the range of possibilities for drawing with ink is very wide. In this project, Josep Asunción wished to explore this medium and experiment with the different types of lines that result from different applicators, the charge of ink, and the form of the line. To do this, he started with the same model and represented it in different ways, combining those drawings to create poetic compositions. He used different artist's colored inks, ink for writing, and India ink, as well as bleach, along with various applicators: pencil, reed pens, brushes, sponges, and nib pens of various shapes. The support is always coated paper and Bristol paper, specially made for calligraphy.

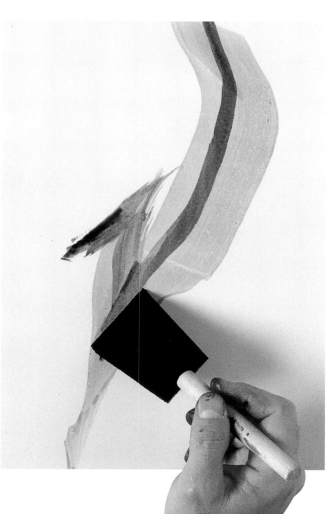

“*In drawing, even when making a single line, each of its parts can have an endless number of nuances.*”

Henri Matisse, *Écrits et propos sur l'art.*

Step-by-step creation

1. The first lines of this composition are drawn with a sponge brush. The shape of the sponge makes it possible to draw very thin or very wide curved lines, depending on the part of the sponge that touches the paper while drawing. The ink is a mixture of writing ink and sepia colored artist's ink mixed with a little water.

4. The work is finished with several more lines. One of them, the widest, is drawn with the sponge, using a more diluted ink and a broken line to create horizontal bands. The others are drawn with the pencil dipped in ink. Varying the modulation creates quick, spontaneous, and sinuous lines.

2. Over that line, when dry, a second, very clean line is drawn with India ink and a reed pen. The combination of lines is the type of contrast that we are looking for; it moves between the parameters of transparent-opaque, oil-water, and narrow-wide.

3. Two more silhouettes are drawn, both with nib pens. The first is done with a thin pen with a round nib and orange artist's ink; the line is quick, clean, and thin. For the second, a very wide calligraphy nib pen and India ink are used. Depending on the angle, very thin or very wide lines are drawn to produce a variety of effects.

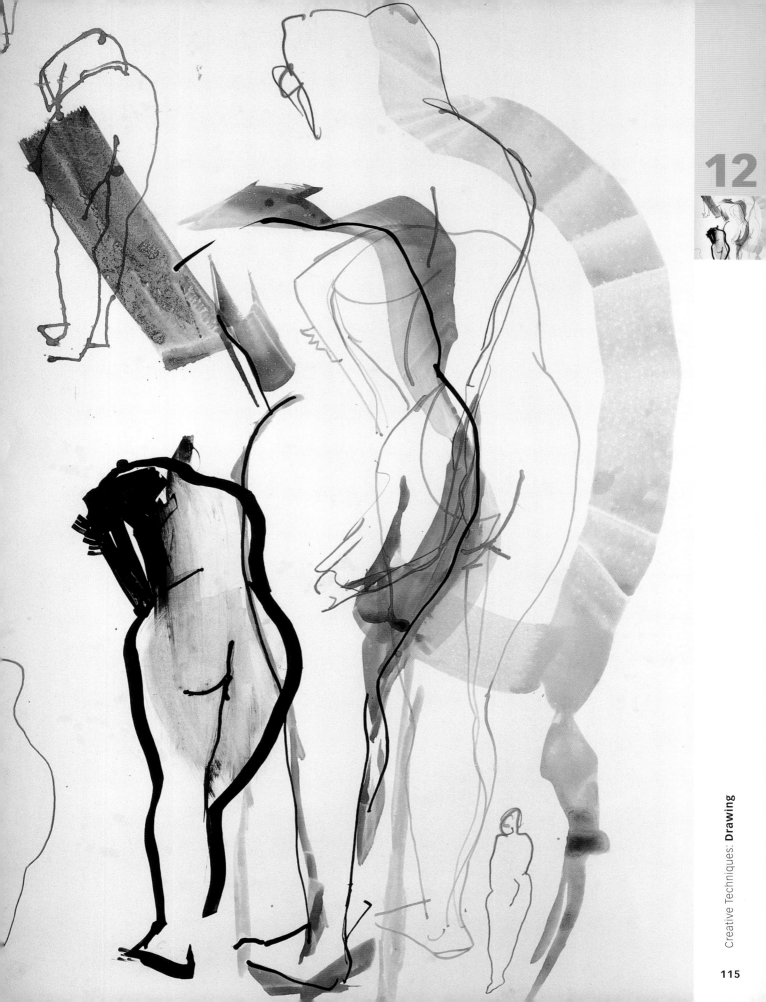

12 Gallery
Other approaches

Different results can be produced simply by changing the applicator—reed pen, pencil, nib pen, brush, or sponge. If in addition to that one takes into account the variety of line shapes—sinuous, shaky, broken up, rigid—and different charges (more or less diluted ink) many different results can be obtained. This gallery shows a few variations.

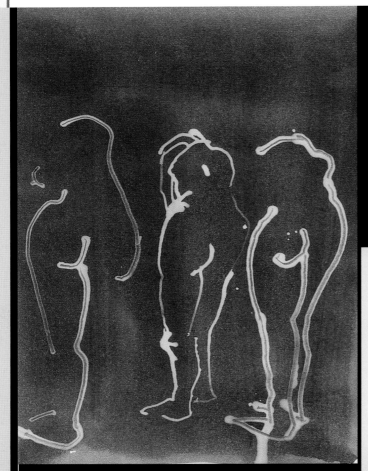

The outline of a nude is sketched over a background covered with a heavily diluted sepia tone that was applied with a large sponge. Blue ink and a flat sponge brush are used for this. The work has been finished with a thin line made with India ink and a round nib pen. The combination of both types of lines creates a feeling of volume.

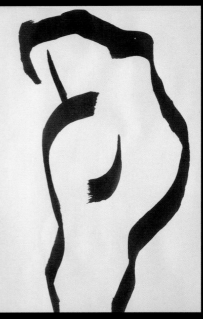

This drawing starts with a background made with black writing ink—Quink ink—made of liquid aniline, not India ink. When it dries, a drawing is made with a pencil that has been previously dipped in bleach to open areas of white. The final effect is a luminous line with a thin gray line inside of it.

This clean and sinuous drawing is made with India ink and a wide bristle brush. Depending on the angle of the brush the line can vary in width. The end of each stroke is serrated due to the effect left by the hair of the brush. This type of stroke calls for a minimal and well-calculated technique.

This work is the most involved of the gallery. It shows the effect of different nib pens in a composition encompassing many nude studies and finished with a background of orange ink surrounding the outlines of the figures. Notice how some of the nib pens provide very unusual finishes, such as the one achieved with horizontal hatch lines.

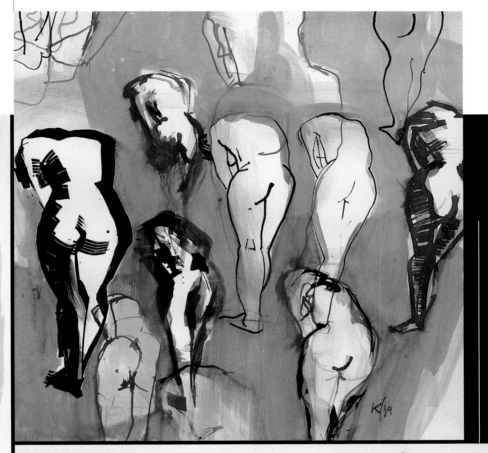

The main characteristic of this composition of outlines is the shaky look of the lines. They have been drawn using a reed pen with tips of different widths, forcing the line to acquire a certain degree of clumsiness.

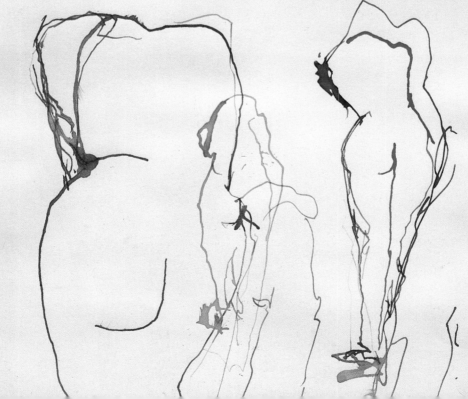

Another view A line can be formed by various parallel or intertwined lines, as if it were a rope. Here, the artist wanted to experiment with this effect, drawing the lines with a brush that leaves several linear marks. To do this he has chosen a fan-shaped brush. The final effect includes a series of hatch lines that have been applied with a single stroke. This approach creates an unexpected textured effect.

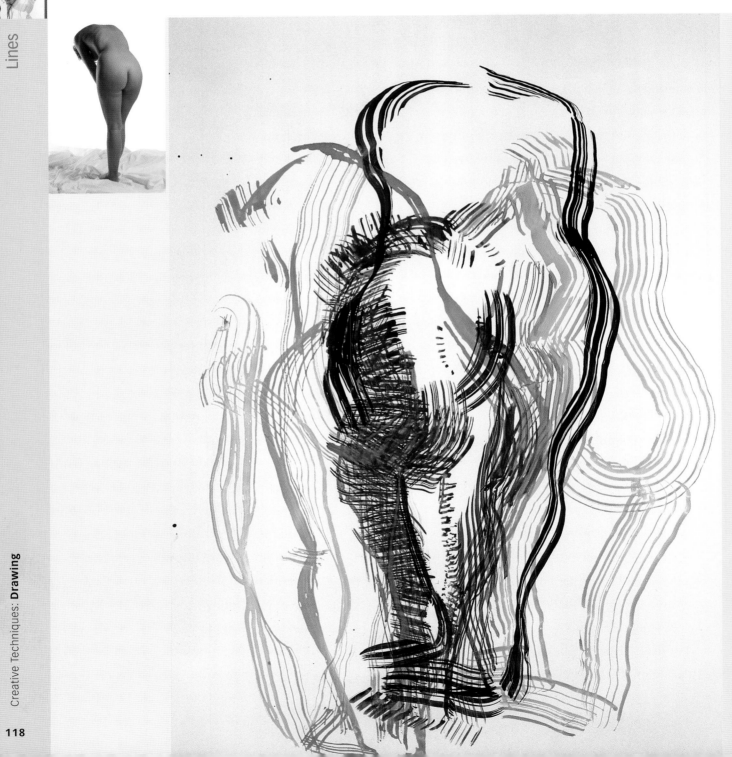

Another model A subject that lends itself to this type of line work is a still life with glassware. The transparency of the material makes it possible to see every line of the object and its representation conveys a magical effect. To experiment with this inspirational motif the artist has approached it from two different angles. In one of the works, full and empty spaces are combined by drawing the lines with India ink using different nib pens and wide lines of transparent ink made with a flat sponge. For the other project, the lines are drawn with a reed pen and the effects of the reflections and the smoothness of the objects are rendered with a synthetic bristle brush.

13 Mixed media
Creative approach

Miquel Barceló,
Fishbowl, 1987.
Private collection.

Because of its fresh and spontaneous nature, drawing is the main tool for the work of Miquel Barceló (born in 1957). He gives it the same importance as painting, and has never considered it a minor medium. In his drawings, he invites the viewer to get close to his world, to observe his concerns and interests in a direct and simple manner. Right from his beginnings in the 1970s, his work on paper has paralleled his work on canvas. The work has continued to capture the moment, to show a world constantly in turmoil, constantly evolving. For Barceló, the art piece arises from the contact with the material, with no other planning process: a ray of sun gives way to an open book, a spiral to a column. His extreme virtuosity has allowed him to draw without any restraints or hesitation, making poetry out of mundane routine. His innovative spirit is present in his use of tools and materials. In his drawings of the 1980s he created art pieces with a unique gesture, like those of Chinese painting. He came up with a method for tying brushes together, which allowed him to draw a fish, a horse, or a landscape with a single stroke. His experimental and unpretentious aesthetic allowed him to use any type of discarded material; it is not unusual to find a cigarette butt, a fly, or even his own footprints in his work. *Fishbowl* is a drawing created with mixed media on paper. In it we can see the attraction for what the artist labels "painting what we can hardly see" (glass, water, and transparencies), which led him to experiment with varnishes and glazes in a pursuit to capture the moment and to discover the mysticism that surrounds the transparencies.

Experimenting with a mixed media still life

Since the beginning of the twentieth century, post-Impressionist painters have conceived of still life as the ideal genre for experimentation. In the same spirit, Gemma Guasch sees this still life as the ideal medium with which to experiment and transgress the classical approaches by mixing dry and wet media. Graphite and chalk have been mixed together with inks and gouache, generating new artistic media and providing results that are less foreseeable and more daring.

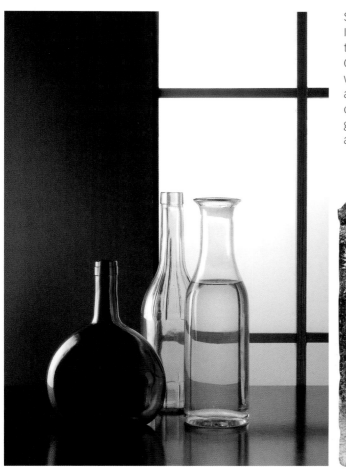

"*I like to come up with different techniques for painting. I do not think them over too much, they are good as they are and that is all. The effect of a piece of black torn paper made me think of fire; the theme came to me as a result of the technique, which happens to me often. First, I do something and then I think to myself 'it looks like the scales on a fish.' So, I paint a fish.*"

Miquel Barceló

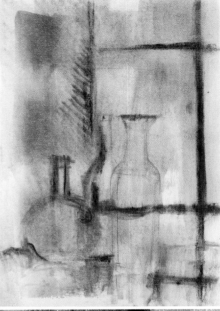

Step-by-step creation

1. The drawing of the still life is sketched on heavy paper using soft graphite. Since the subject matter is transparent bottles, the shadows and the forms that can be seen inside of them are also drawn.

2. A layer of blue artist's ink is applied with a sponge roller. Then, the structures of the background and part of the bottles are marked with graphite powder. Next, a blending stick introduces the pigment, creating more airy and blended areas.

3. Using a reed pen charged with India ink, hatch lines are drawn to darken the background. Once dry the entire paper is painted with white gouache using a dry wide brush. This creates a coarse texture, which produces a partial glaze over the still life.

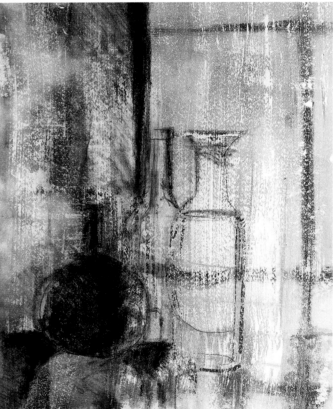

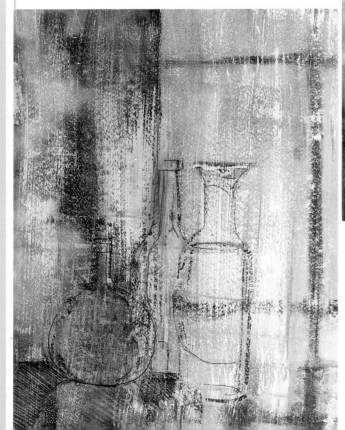

4. When the gouache is dry, the left side of the still life is darkened with black chalk, charcoal, and graphite powder. The application of dry media over wet must be done carefully to avoid damaging the paper's fibers.

5. To balance the coarse texture of the gouache, a new similar layer is applied by painting and washing. The left side of the drawing is painted with blue violet artist's ink. Finally, colored chalk is used to apply a few indications of light, which bring out the transparency of the bottles.

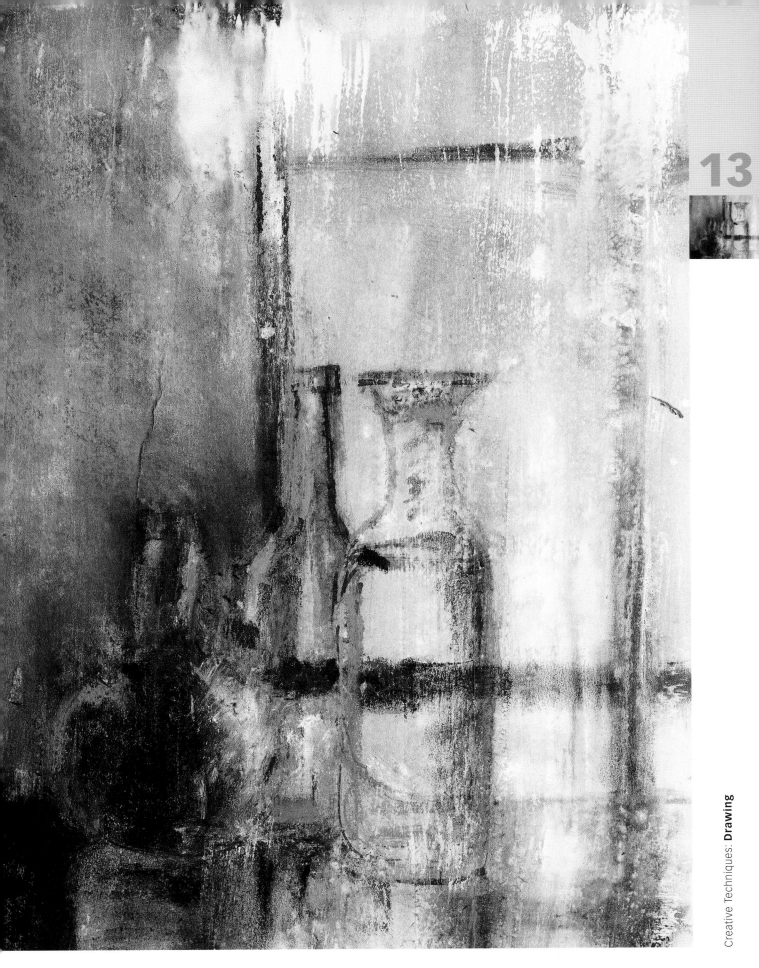

13 Gallery

Other approaches

As we continue to experiment with mixed media, we have developed a gallery where all the different techniques are showcased. Oil crayons, watercolor crayons, graphite, inks, chalks, and pastel all provide new creative approaches with endless possibilities.

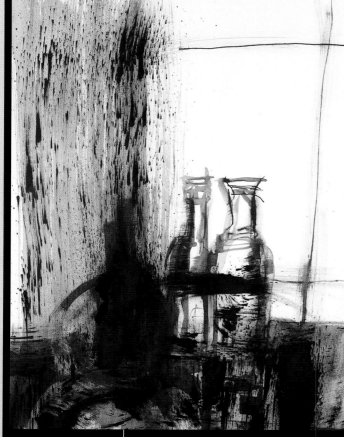

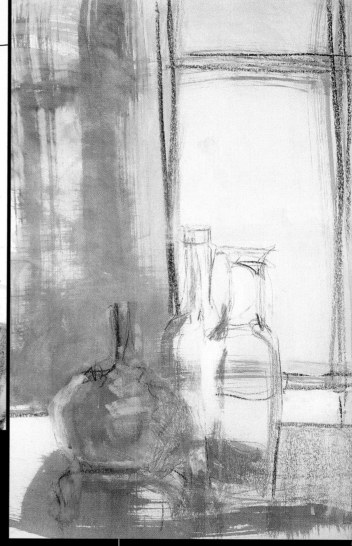

This drawing has been sketched with graphite powder and India ink applied with a reed pen. The transparency of the bottles has been defined with blue artist's ink. Finally, black gouache has been applied dry over the wall and the table. The result: a fresh and casual drawing with quick, direct, and spontaneous strokes.

This still life has been sketched with watercolor crayons. Then some areas have been painted with a warm gray gouache, making use of the white texture of the paper. The results are fresh and whimsical.

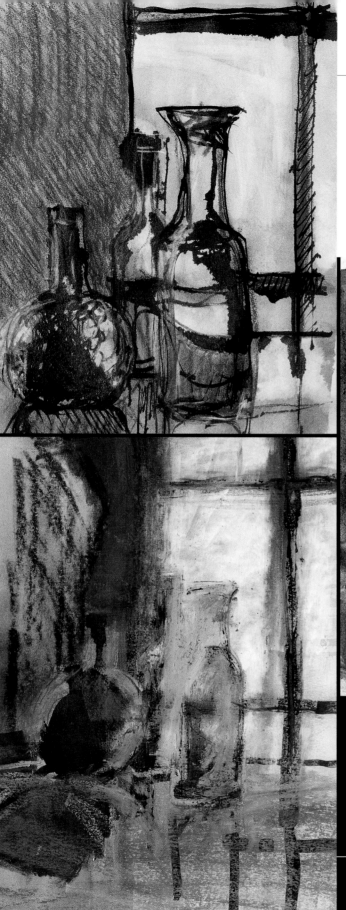

In this composition, India ink is applied, first with a sponge and then with a brush. Once dry, it is partially covered with blue artist's ink. When the ink is dry it is worked over with different colored chalks, a combination that creates interesting textured effects.

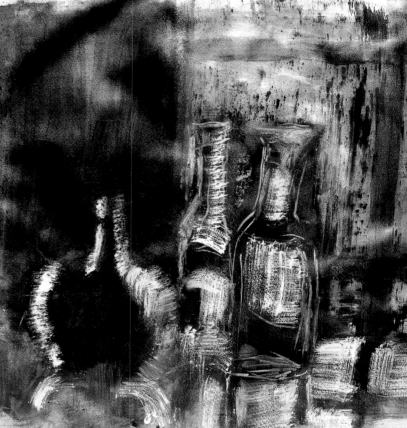

This is the gloomiest still life of the gallery. This effect is the result of the presence of black throughout the work. The mixture of ink, charcoal, and gouache creates soft black atmospheric effects. Over them, the areas of light are suggested with white gouache, applied with a dry brush.

This work begins with a suggestive atmosphere created with artist's ink mixed with graphite powder. The still life is defined with short, quick lines and strokes of India ink applied with a reed pen. Finally, the random hatch lines are drawn with watercolor crayons.

Creative Techniques: **Drawing**

Other views Collage lends itself to the use of mixed media in an experimental way. Here, Gemma Guasch blends the two. The shapes of the bottles and the area around them have been resolved with magazine and drawing cutouts recycled by the artist. The paper is painted with blue artist's ink and India ink. Collage pieces are then glued to it. The work is then finished with a covering of white gouache to unify and highlight its textures.

Other models Still life subjects offer a wide range of possibilities; in this case, the artist has chosen geometric shapes constructed from paper to create a different look. The white folded paper and the light of its shapes generate an attractive world of light and shadow. In this still life, the artist again uses mixed media. Here, the white and opaque forms of the still life stand out against the dark background through the effect of the white gouache and the lines drawn with blue chalk.

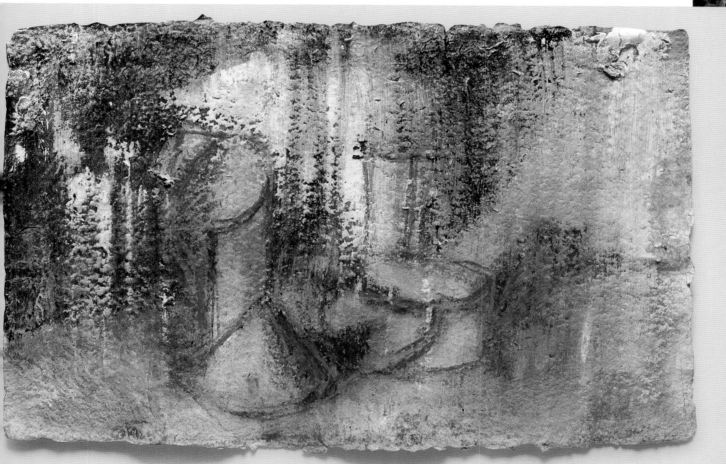

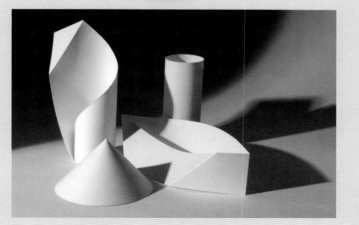

14 Zen drawing
Creative approach

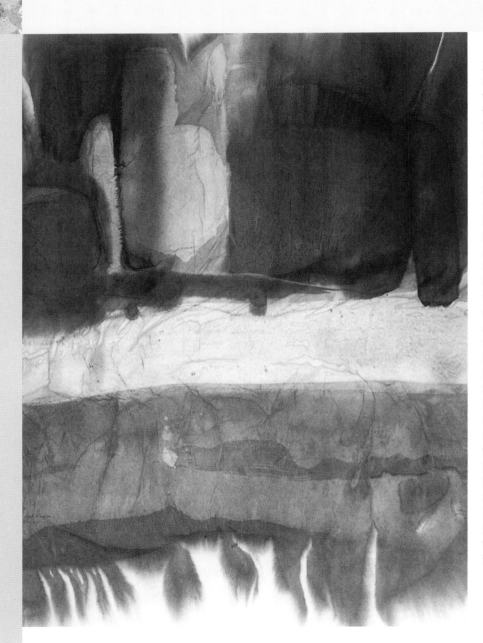

Zen drawing is deeply rooted in the tradition of Chinese painting, the history of which dates back to the Han dynasty in the second century B.C. This art form became a Taoist spiritual tradition in China and was later enriched by Zen philosophy. It was during the Tang dynasty, between the seventh and ninth centuries, that a fundamental concept of this art was developed: emptiness. It reached its pinnacle during the Song and Yuan dynasties between the tenth and fifteenth centuries. During the second half of the twentieth century, deep connections were established between the Eastern Zen aesthetic approach and Western painting by European and American artists of the Informalist movement, including Antoni Tàpies, Hans Hartung, Marc Rothko, and Barnett Newman. Today, this work transcends the physical and cultural barriers of the East and is practiced worldwide. A renowned artist in this movement is Gao Xingjian (born in 1940), a poet, playwright, theater director, and painter who received the Nobel Prize for Literature in 2000. Gao Xingjian's work represents a true bridge between East and West, between tradition and innovation, the figurative and the abstract. With his works in ink, the artist proposes a return to feeling, nature, and humanness.

Gao Xingjian,
An instant, 2001.
Private collection.

Zen-inspired abstract drawing with India ink

In this final project, Josep Asunción immerses himself in the wide world of experimental Zen drawing. Choosing fire as the model and visual stimulus, the artist gets in touch with his *Li* (the internal line of things) and expresses its rhythm and movement with abstract brushstrokes; through the behavior of the ink he expresses its light and shadow. In this series of exercises, he applies the fundamentals of Zen drawing—the basic brushstrokes (frontal attack, sweeping, colors without lines, syncopated cadence, spattering) and a single line within the empty space—directly and without hesitation. The materials he uses are always the same: India ink and brushes of various shapes and sizes on paper.

" Emptiness is within the images, but also outside of them; it is a form of liberation and a spiritual state all at the same time. Man is limited by a given time and space and Zen can be an inspiration for the artist who lives in a real world and wishes to liberate himself from it."

Gao Xingjian, *For a different approach,* 2004.

Creative Techniques: **Drawing**

Step-by-step creation

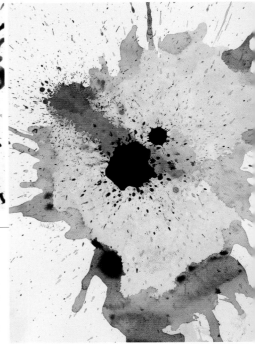

This drawing employs the *pomo* technique, a term that refers to the breaking or splashing of the ink to create areas of color with irregular edges. In this instance, the ink is splashed to experiment with its blending capability. The tradition distinguishes five levels of color: burnt black, concentrated, dark, diluted, and light. This work is developed in four well-defined steps: a first pomo of light ink, a second one of concentrated ink, a third one of blended, burnt ink that dilutes the concentrated ink to create color reflections and dark areas, and a last application of concentrated ink. The ink is allowed to dry between the third and fourth stages to create gradations.

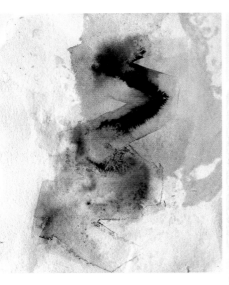

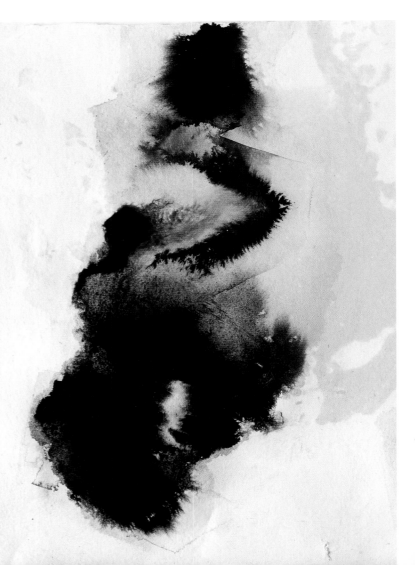

A new piece created with the *pomo* technique, this time resulting in an area of color without edges or with blurred edges. *Pomo*, as broken ink, produces an atmospheric or foggy effect that holds emptiness within because of its lack of definition and detail. Work is done in three stages. First, a well-defined area of color is created in a zigzag shape. Next, a wash is applied over it with a sponge soaked in water. With the paper still wet a similar color shape is made with ink, which now bleeds to form a blurry and airy atmosphere. The support is handmade paper in two colors, white and light green.

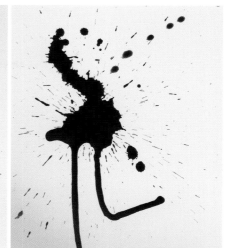

A basic element of Zen is movement, and with it comes change. Zen meditation focuses on breathing to capture and live the moment, to create a space and emptiness between the before and the after, memories and desire. A classic image of this philosophy is water on river pebbles; the water keeps moving over and around the pebbles to adapt to their shape until it blends with the current once again. By letting the drops of ink spread all over the paper without using any applicator, relying on chance and accident, this drawing re-creates the movement and the change that lives within fire.

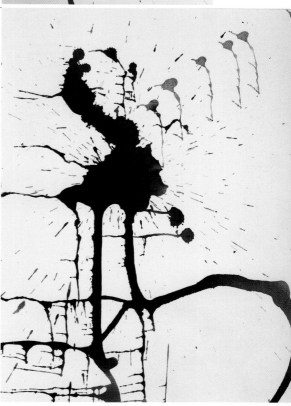

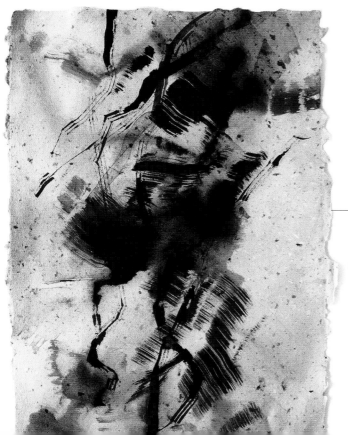

This time the brushwork follows three techniques. The first is *duncuo*, syncopated cadence, using a wide brush with a small charge of concentrated ink. After the ink is dry, work continues with *qifu*, undulating movement, using a medium round brush with a generous charge of ink. It is finished with *zheng-feng*, frontal attack, using a brush charged with water so the ink from the wavy lines blends with the wet areas to create atmospheric effects.

14 Gallery

Other approaches

The multiple combinations of brush and ink techniques alone can produce countless images. But this entire gallery would only be a repertoire of effects if it did not include more expressive and spiritual elements. As Gao Xingjian said, referring to the first abstract Zen ink works, *"They did not try to re-create images, but inner states of mind."*

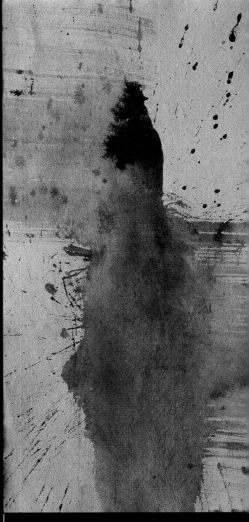

With respect to the technique of this work, *feibai*, or flying white, Chen Yaotian wrote *"…it glides through the paper like a pure spirit who, on its way, fills up the space with its presence without leaving any tangible traces."* This is one of the brushstrokes that represents more clearly the internal emptiness; it is created with a brush in which the hair has a separated configuration, rather than massed. The brush-stroke leaves unpainted spaces, as if the air had blown holes in it; this is how the feeling of union between mass and nothingness is created.

The ancient Chinese masters said that a space can be so full that even air cannot get through, and at the same time contain enough space within which a horse could easily frolic. In this work, which looks dense and dark, the artist has represented emptiness through the central gap and the ink gradations. A wide brush is used to work through different layers of ink and different levels of solutions.

This work attempts to achieve the supreme objective of Chinese painting: to encourage rhythmic breathing. Shen Zongqian wrote, *"The handling of the brush must be controlled by the breath. When the breath is, the vital energy is; then the brush truly creates what is divine."* Two techniques have been used: *zheng-feng*, frontal attack, and *tuo*, sweeping, with diluted ink on

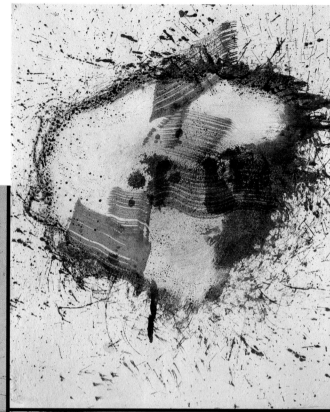

This drawing begins with a *pomo*, spattered ink, to create a very large, diluted area. Next, *ca*, rubbing, is applied inside the large area, using a wide brush soaked with mineral spirits and following quick circular motions to splash and to open a light area. Referring to splashing and lines, Huang Binhong wrote, *"Each dot has its own existence; it promises multiple transformations. Making a dot is like sowing a seed; it must grow and become."* And regarding creating light areas, *"A painting begins with brushstroke-ink to arrive at no-stroke of the brush-ink. Beginning with what is light and tangible to arrive at the 'explosion of emptiness'…"*

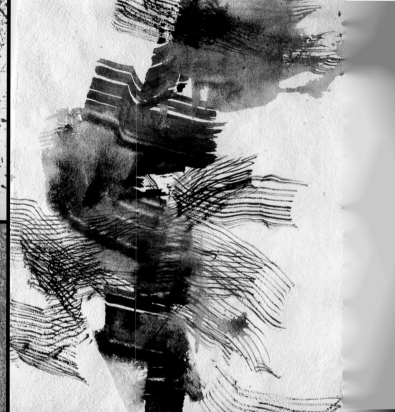

Traditionally an ink drawing should contain two-thirds emptiness to one full. Huang Binhong wrote, *"Painting is like playing the game of go. The idea is to get the most points available on the board. The greater the number of points, the greater the chances to win would be. In a painting the available points are the emptiness."* This proportion of emptiness can be the unpainted paper, fogginess, or lack of definition. This drawing aims at that proportion and the techniques applied are *duncuo*, syncopated cadence, *qifu*, undulating movement, and *feibai*, flying white.

The texture of this ink was achieved by applying salt while the ink was still wet. The black ink contains many strokes and suggestions. Tang Yifen wrote, *"We try to change the colors to break up the monotony, but are we aware that a single color can change endlessly? This single color makes it possible to distinguish between yin and yang. And how superior is the ineffable beauty of a colorless state!"*

Other views Most Chinese paintings and, by extension, Zen drawings, are created with black ink, taking full advantage of its shades. But there is also a tradition of color paintings executed with mineral inks called "gold and jade." To illustrate a new approach, the artist experiments with the drawing, incorporating artist's colored inks. The result is equally poetic and expressive, although less striking, because the color adds more strokes to the visual discourse. The artist has created empty spaces with bleach, which in turn creates areas of light within the colors.

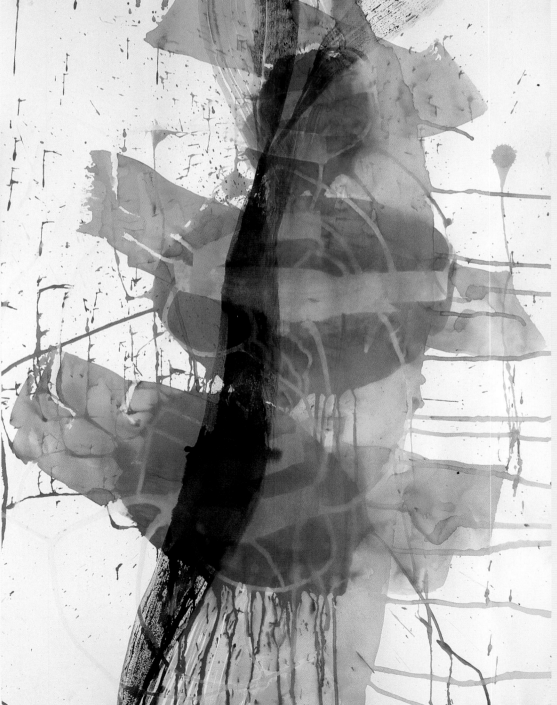

Other models In every Zen drawing and Chinese painting before or contemporary to Zen, there is a maxim: The goal is not to represent the model, but to re-create it. A pillar of Zen painting is to search for the *li*, the internal law or internal line of things. Referring to this, Zong Bing wrote in his famous *Huashanshuixu* text, *"Besides, the spirit has no shape of its own; it acquires its shape through things. The idea is therefore to draw the internal lines of things through brushstrokes inhabited by light and shadow. When things are thus received adequately, they become the representation of truth itself."* As a variation of the model, Josep Asunción has chosen a few branches, an inanimate natural object. After contemplating them and searching for their *li*, he re-creates their spirit in a few abstract ink lines. He has applied the *pima* brushstroke, disentangled hemp, and *qifu*, creating undulating lines.

Form

Form and how it is perceived

Form is, on one hand, the external appearance of objects, and on the other, the mental model that helps us identify them. We recognize forms through their structure, which is determined by the edges of the object or its interior skeleton. In the act of perceiving we relate the structure to experiences that have previously accumulated in our memories. Perceptively, we do not need complete

BASIC CONCEPTS

Abstraction

An abstraction is an image in which forms seen in reality cannot be identified. This does not mean that reality has no abstract forms; we can look at the distressed finish on an old door, the structure of a building, or look through a microscope to convince ourselves of this fact.

Abstraction with wax crayons

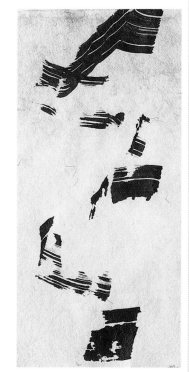

Zen abstraction

Values of light in chiaroscuro

Chiaroscuro

Forms can only be seen because they reflect light. But light creates shadows, which are as important as the light, as are all the intermediate values. Chiaroscuro is the name we give this play of light and shadow.

Outlines

Outlines do not exist in reality; they are a linear interpretation made by the artist to indicate the edges of forms in respect to other forms or to the background.

Blurring

This is a technique in drawing and painting where the form is erased, deformed, or overlapped by other marks, and ambiguities are created to move the drawing

Outlines

away from a formal correctness. The goal of this is to emphasize expression over representation.

Blurring

Skeleton

The skeleton form is the internal structure that every object has. Sometimes this skeleton is real, as is the case of the human body; other times it is a geometric figure that the form could contain, such as a sphere, a cube, or a cylinder.

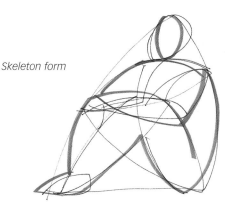

Skeleton form

information to recognize a form (in figure A we recognize a square by only its corners); furthermore, we can control perception since it is a mental process and not merely a reflex (in figure B we see upward pointing arrows or downward pointing arrows, according to our wishes).

Mass

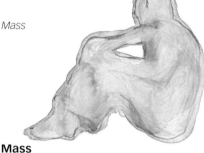

Mass

This refers to the space that a form occupies in the drawing. Mass implies a visual weight and that weight is determined by the form's size and the density of its color and light. A large mass of light or diluted color weighs less than a smaller mass of dark or dense color.

Modeling

This is the treatment applied to the form to create a sense of volume. If wet media are being used it is a matter of adding and removing color, controlling the intensity of the tones, and the amount of dilution. In dry media, hatching is used to regulate opacity according to the intensity of the lines.

Modeling with hatching

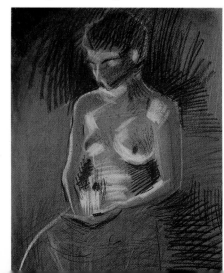

Layout

The first steps of a drawing are very important because they distribute the elements that make up the image. A form is laid out from inside to outside, that is, from the essence to the details. In this manner, one method of laying out a drawing is blocking, which consists of putting the forms in "boxes" or basic shapes (cylinders, cones, spheres, cubes, ellipses). A less academic method consists of applying a series of intuitive marks, each is based on the previous one.

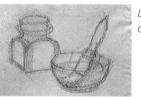

Layout with outlines

Layout with color strokes

Silhouette

This is defined by the edges of the mass in space. The silhouette shows no details, but describes the form if the pose is good.

Silhouette

Synthesis of line

Synthesis

Synthesizing reduces information to a minimum, leaving only the essentials for understanding the form. You can synthesize with line by reducing the outline to the minimum, or you can use strokes and color to work with the silhouette or chiaroscuro, based on values of light and shadow.

Tenebrism

This term has its origin in Baroque painting. A work of art is considered tenebrist when the light emerges from darkness to cause a certain theatrical effect.

Tenebrism

Volume

This is the three-dimensional aspect of the form. In drawing it is defined by chiaroscuro. The term is also used to refer to the amount of visual presence of an image. An image has volume when it contains contrasts that make the form stand out.

Creative Techniques: **Drawing**

137

Color

Color and how it is perceived

Color is a perceptive phenomenon. Objects are not a certain color, rather they are perceived in that color in determined conditions of light. A sheet of paper is perceived as white in the sun, blue gray in the shade, and yellowish in the light of a lightbulb.

Isaac Newton (1643–1727) discovered that white light breaks into a chromatic spectrum when it goes through a transparent prism. This is the same phenomenon

BASIC CONCEPTS

Color wheel

If you join the first and last colors of the chromatic spectrum (magenta and violet), they form a wheel. In this wheel there are three pure colors that cannot be created by mixing: magenta, lemon yellow, and cyan blue. Mixing these primaries with each other creates the secondary colors: orange-red, bright green, and blue-violet; mixing the secondary colors creates the tertiary colors: green-blue, yellow-orange, etc.

Chromatic chiaroscuro

There are two kinds of color chiaroscuro, value and colorist. Value chiaroscuro uses a color that goes from the lightest tone, mixed with white, to the darkest by mixing it with black, or with its complement if cleaner color is desired. In this case we are talking about using pigments that are naturally bright or dark.

Adjacent colors: Adjacent colors are two that are near each other on the color wheel.

Warm colors: On the color wheel this is the range that goes from violet to yellow-green. Visually they give a sense of heat. Black is neutral, but it tends toward warmth.

Warm colors

Complementary colors: Two colors are complementary when they are at opposite sides of the color wheel.

Pasty colors: In a painting, when the colors in one area are very similar in shade, value, or both, they are said to look pasty.

Cool colors: On the color wheel, this is the range that goes from blue-violet to green. Visually they lend a sense of coolness. White is neutral, but it tends toward coolness.

Cool colors

Neutral colors: A color is neutral when it has been mixed with its complement. It looks gray and dark because it has lost its brightness. Neutralizing a color is the natural way to darken it.

Neutral colors

Pastel colors: These have a pastel tone; this is the case when they contain white and are thus lighter than they normally are.

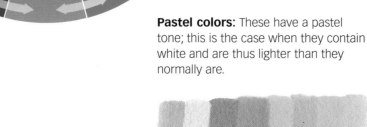

Pastel colors

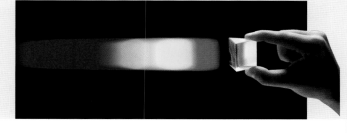

that takes place when sunlight goes through raindrops and creates a rainbow—the colors of the rainbow are those of the chromatic spectrum. When light strikes an object it absorbs all the colors of the spectrum except one, which is reflected back at the viewer. This is the color of the object in those conditions of light.

Saturated colors: A color is saturated when it does not contain any of its complement, nor black, nor white. That is to say, it is absolutely pure, with all of its natural energy.

Saturated colors

Contrast

There are three kinds of chromatic contrast. *Tonal contrast* is produced between different colors from the wheel; the greatest contrast is between complements. *Value contrast* is between light and dark colors. *Saturation contrast* is between a saturated color and a neutral color. In this, an extreme contrast will be produced between a pure yellow and a grayed dark violet, or between a maroon and a bright green.

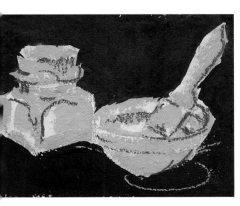

Contrasting complementary colors

Range

This is the name for the group of colors that have been used in a work of art. It is sometimes called the harmony, because it refers to the way the colors interact. For example, a monochromatic range is based on a single color, while a harmonic trio contains the colors found at each corner of an equilateral triangle placed over the color wheel.

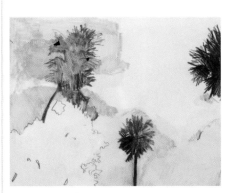

Monochromatic range

Harmonic trio of primary colors

Tone

This refers to the position of a color on the color wheel, but not its value or saturation. It is also used in the same sense as shade; thus, a color can have a bluish, orange, or bright-red tone, or shade.

Value

This is the light or brightness of a color. On the color wheel the brightest color is yellow and the darkest is violet, but each color can be lightened or darkened and move toward white or black.

If we dilute coffee with water we lighten its value while keeping its tone intact, but if we mix it with milk we lighten it and create a pastel color. The same thing happens with paint if we lighten a color by diluting it or by adding white.

Chromatic contrast

This is a popular concept that refers to the contrasting colors in a drawing. They can create a vibration that is very subtle or very intense, depending on the application.

Space

Space and how it is perceived

We perceive space visually because of two factors: light and perspective. Light makes the perception of volume and depth possible, while perspective helps us establish relationships of distance. Things that are closer look larger and clearer and have more contrast. Let's look at some perceptive phenomenon related to space: Gradations **(A)** provoke a visual sense of depth; in general, darkness evokes distance more than light. Perspective basically works with the diminishing size

BASIC CONCEPTS

Atmosphere

In drawing, atmosphere is what gives a sense of humidity and density. When a drawing has atmosphere it seems that the strokes fill the air with particles, and they make it dense and tactile, like steam, fog, or dust. An atmospheric drawing often uses blending, layers of glazing, and dry brush lines to reduce clarity.

Atmosphere created by glazing

Composition

This refers to the distribution of the elements of a drawing. It indicates the artist's expressive intention and establishes a visual path from the central elements that capture attention to the secondary and marginal aspects.

Framing

This is the selection of the scene. Framing includes the format (square, landscape, etc.), proximity (moving closer or farther from the scene), and point of view (lateral, frontal, angled, etc.).

Compositional scheme

This is the synthesis of a composition, the general scheme of the distribution of the elements. The most widely used compositional schemes are the centered composition, which centers the subject in the picture and is very static and balanced (1) and the orthogonal composition, which is based on vertical and horizontal lines (2). Diagonal compositions are another more dynamic scheme (3).

1

Centered composition

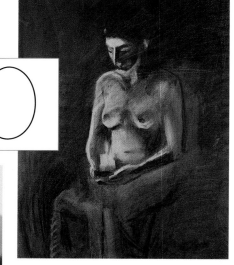

3 *Diagonal composition*

Framing a landscape

of objects **(B)**. Overlapping **(C)** consists of defining planes of proximity by partially covering the represented objects, the nearest partially hides the others. Finally, the play of focus/out of focus can create distance **(D)**, an approach learned from photography.

Figure and ground
This refers to the relationship established between the figure and the background. It requires a decision regarding whether they should or should not be separated visually. The background can be considered a basic part of the artwork, not just the physical support. To integrate the background and the figure well, it is best not to accentuate the contrast between the two.

Format
By format we understand the shape of the support, although this term can also be used to designate the sizes of artworks (small format, large format). The most common formats are 9 × 12, 12 × 18, 24 × 30, and 30 × 40 inches. Metric standard formats: 50 × 65 cm, 50 × 70 cm, and 70 × 100 cm.

2

Orthogonal composition

Linear perspective
Perspective is used where a space is defined by lines (streets, houses, interiors, etc.). It is based on the following phenomenon: lines that in reality are parallel are perceived to meet at a point on the horizon, which is always at the same height as the viewer's eyes. Depending on the person's position in respect to the space, the perspective can be one point (only one vanishing point), or oblique (with several vanishing points).

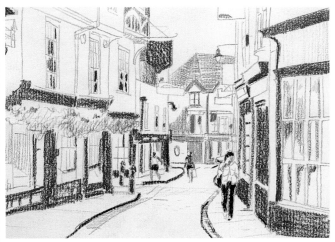
Linear perspective

Proportion
In drawing, proportion and scale are very similar concepts, because both refer to the relationship of size or distance between two objects. To create a sense of space it is common to exaggerate the proportions.

Point of view
This is the position of the artist in relation to the subject he or she is rendering.

Rhythm
This is the unity in change and variety. Rhythm creates a sense of movement in the artwork. It is produced by the repetition or alteration of forms following a cadence. By varying the intensity or the positions of the objects, we can cause visual movement and use it to direct the eyes of the viewer. Fullness has as much importance as emptiness in rhythm, just like sound and silence in music.

Projected shadow
Projected shadows are the silhouettes of forms on the ground, caused by the position and intensity of the light on these forms. It is a technique that creates a sense of spatial depth.

Line

Line and how it is perceived

Line is the physical dimension of the drawing. While form, color, and composition refer to the "what" of the image, line refers to "how" the image was physically created. It is closely related to the materials and the intentions that went into the construction of the image, basically related to two aspects of the work: texture and gesture. In the first case material factors are involved (the support, material,

BASIC CONCEPTS

Gradation

When the passage of one color to another or one gray tone to another is gradual, we call it a gradation. It can be blended, even very gradually, or not, so that each step of the flat or textured color can be seen.

Blended gradation

Gradation without blending

Blending

This is a color or stroke that is created when we gently rub, leaving no trace of the original line. Generally, a blended surface creates a soft atmospheric effect.

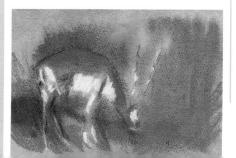

Gesture

Gesture results from the modulation of lines. It is related to the movement of the hand, and by extension, the arm and the position of the body. Today it is perfectly normal to have an understanding of gesture drawing, but this is recent and is due to the rich influences of Eastern painting, with a long tradition in this area. Other factors include twentieth-century Western influences like Abstract Expressionism and the work of Pablo Picasso.

Gesture drawing

Intensity

When talking about the wet media, this refers to the amount of ink that is held by the applicator. With dry media it describes the amount of pressure applied to the applicator (pencil, stick, etc.).

Above: *intensity in a dry medium*
Left: *blended strokes*

Wash

Washing means eliminating the color that has already been applied and that is at a more-or-less advanced state of drying. To wash a drawing, or a part of one, a diluent is applied directly or with a rag or sponge and then dried with a rag. By controlling the flow of the water and the pressure during the washing and drying you can create more or less dense atmospheres and leave ragged edges on lines and brushstrokes.

Wash over India ink

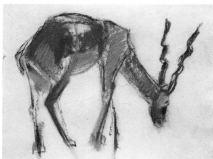

Intensities in a wet technique

A B C D E F

and applicators); in the second, factors of technique (speed, intensity, and modulation). Using the same model we can express ourselves differently with a quick brushstroke with a lot of spattering **(A)**, a slow line with little color over a wash **(B)**, dabs with a spatula full of paint **(C)**, a fluid, slow, and precise brushstroke **(D)**, atmospheric strokes applied deftly that both deposit and absorb the color **(E)**, and a thin, controlled, scratched line **(F)**.

Juxtaposed strokes

Juxtaposed and overlapping strokes can create transparent effects. When a stroke of transparent color covers another, a visual blend occurs. This is one of the most popular techniques when working with glazes.

Juxtaposed strokes

Modulation

This is the form of the line, a form that is determined by the movements of the hand. We can draw lines that are sinuous, shaky, jagged, straight, loose, or spidery.

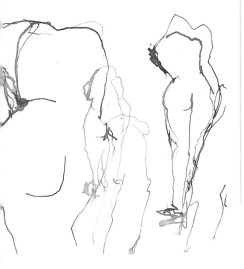

Texture

This is the tactile dimension of the drawing. It can be a visual texture created with hatching, brushing, spattering, transfers, or dripping, or a tactile texture based on impasto, collage, and supports with relief. The textural dimension of a drawing adds expression and communicates a greater sense of reality, contributing to the virtues of the image.

Visual texture

Hatching

This refers to the shading normally created by parallel lines that are crisscrossed. The grid that results can be more or less dense and produce a determined value in a chiaroscuro. Hatching can also be done with dots, although this is less common.

Fine, shaky lines

Glazing

A glaze is an area of color, of any size, made with paint that is very diluted with water, a solvent, or a medium. The diluted color is more transparent and allows the colors that may be underneath to show through. This is the most typical way to apply a glaze, with juxtaposed colors, although they can also be applied and later washed to make gradations on the support when the layer is still wet. Glazing creates a translucent appearance, adding not only atmospheric effects, but greater depth to colors and grays.

Glazing

Hatching

Creative Techniques: **Drawing**

143

CREATIVE PAINTING

FORM
COLOR
SPACE
LINE

FORM
CREATIVE PAINTING SERIES
BARRON'S

COLOR
CREATIVE PAINTING SERIES
BARRON'S

SPACE
CREATIVE PAINTING SERIES
BARRON'S

LINE
CREATIVE PAINTING SERIES
BARRON'S